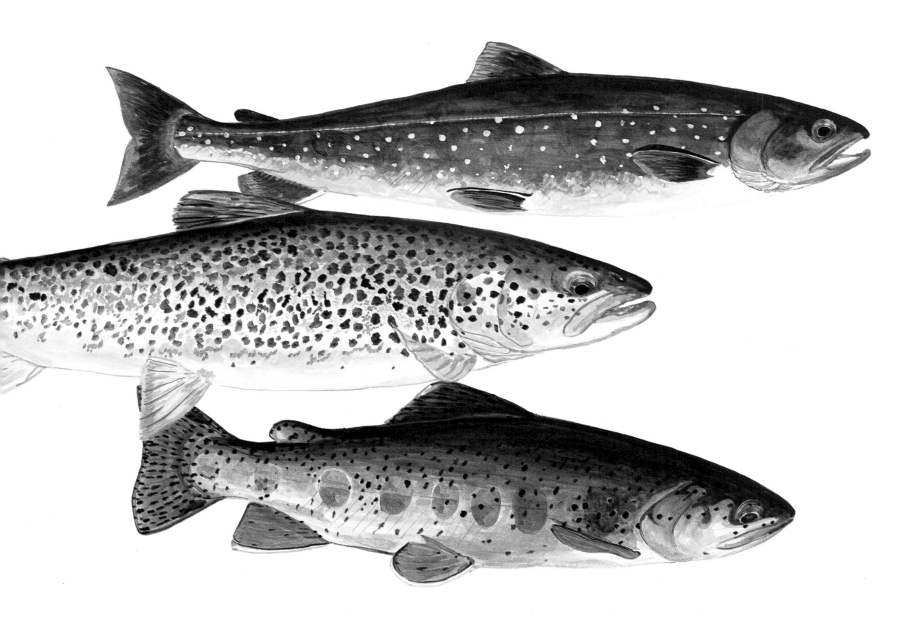

TROUT

AN ILLUSTRATED HISTORY

by James Prosek

ALFRED A. KNOPF NEW YORK 1996

THIS IS A BORZOI BOOK
PUBLISHED BY ALFRED A. KNOPF, INC.

Library of Congress Cataloging-in-Publication Data

Prosek, James, [date]

Trout : an illustrated history / by James Prosek.

p. cm.

ISBN 0-679-44453-X (alk. paper)

1. Trout—United States. 2. Trout—United States—Pictorial works.

I. Title.

QL638.S2P75 1996

597'.55—dc20 95-24808

CIP

Manufactured in the United States of America

Published April 14, 1996

Second Printing June 1996

Frontispiece, top to bottom:

Sunapee trout, brown trout, Apache trout

CONTENTS

BROWN TROUT AND ATLANTIC SALMON

TROUT

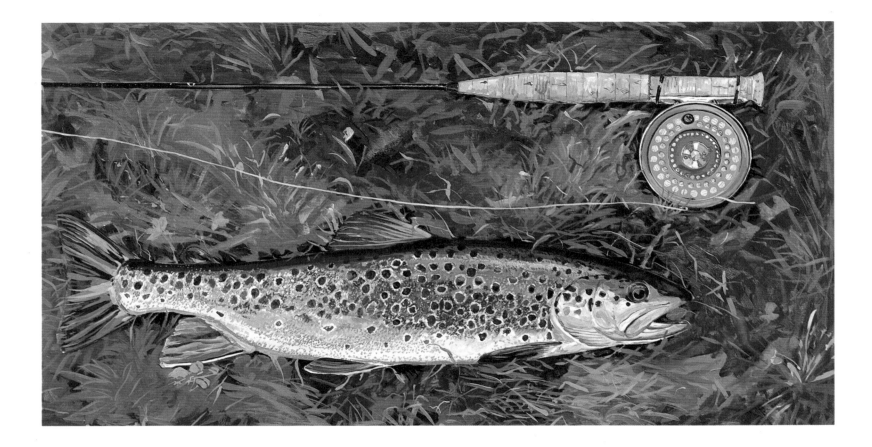

INTRODUCTION

One of my greatest passions in life is fishing. For me it's more than a pastime or hobby; instead it is a way of life, and an escape. The environment of the stream is peaceful. The sound of the water over the rocks is soothing, and any sound of civilization is muffled by the trees. This solitude allows one to brush aside daily life and focus on the task at hand: to catch a fish. The brook, then, with all its colors and sounds, is an education, a place where I can learn about myself and other creatures as well.

The instructive nature of the trout stream is not forced upon its visitors, but held candidly by the water and the trees. The angler must make an effort to hear the stream's messages and see her beauty. I had learned superficially how to catch a trout—first with a worm and then by tying and casting flies—and when the trout would feed and on what type of insects. But my education really began once I'd spent enough time near my local stream that I could begin to understand her language. Only after I'd become comfortable with her modes of speech—winter silence, springtime growling roar, lazy summer trickling, and autumn calm—did I begin to understand that the stream was not only a place where I fished but also a living, breathing celebration of hardship and joy. My interest in the trout of North America grew out of this relationship with my home ponds and streams, which prepared me to explore the far corners of our beautiful continent and the personalities of innumerable kinds of trout.

It was my father who introduced me to nature and the security that she afforded, my father who first extended my hand to meet hers. His lifelong love of birds influenced me greatly, though I followed not birds but trout into nature's heart. My father's life and interests are the essential foundation of my own desires.

He and my uncle lived a carefree childhood in the heat and brilliant sun of coastal Brazil, where they were born. In the port city of Santos, they went to Catholic school in white uniforms and played in palm and lemon trees. Other than soccer, which consumed most free daylight hours in the streets of town, their untiring occupation was the hunting and capture of the sprightly songbirds that flitted from tree to tree in

colors beyond imagination. If not testing their skills with slingshots, they would employ devices of live capture, collecting these vivid ornaments for the large cage on the veranda of their home. Here, shaded from the stifling heat, my father would sit and pore over his six treasured volumes of *The Arabian Nights* in Portuguese. Occasionally he'd pause to lift his head, dreamily caught in the melodious song of the caged birds. Their living colors drew his gaze, and before long he was enamored of them. These feathered spirits would become his life companions on whatever road he traveled, and though their songs and colors would vary as times passed and places changed, they would always be his guide.

When my father was twelve, his family left the lazy haze of Brazil on a passenger ship bound for New York City. Both he and his brother longed for the days of sun and palm trees in which to climb, but at the same time they could not help marveling at their new environs and the wonder of their first winter storm. Yearning for a familiar sight or sound in such an unfamiliar place and season, my father found delight once more in birds. He sat by his window and watched them as they foraged in the falling snow.

Years later, after he and my mother married, he left his job as officer and navigator in the merchant marines. After some frustration at other jobs, he decided that teaching would be his profession and southwestern Connecticut his home. The birds, he often tells me, had led him to all good things. He chose the house in Connecticut not only because it was near the planetarium where he would teach children about stars, but also because of the bird sanctuary in the nearby town of Fairfield. His free time was spent with a pair of binoculars and a guidebook in the woods, where he taught himself the names and habits of all the local birds. After years of watching them, he found that his favorite birds were warblers—tiny and colorful phantoms that flitted from tree to tree, reminders of things he once knew but had never forgot. In my earliest years my father carried me on his shoulders down to the big red barn at the end of our street to watch the swallows as they chased insects and darted in and out of the barn tending their young. From this time it was certain that my father's love of birds and nature would soon be my own.

My initial interest in birds was not so much in wooded glens as in the pages of a book. For days on end I pored assiduously over John James Audubon's bird paintings of North America. The original edition of 1830 was called the Elephant Folio and displayed the birds in life size on 2½-by-3-foot sheets, with the name of the bird and the plant that provided its background at the bottom of the page. A smaller, modern edition spent more time on our living room table than in our local library. With my set of colored pencils and paper, I copied his feathered figures over and over.

Louis Agassiz Fuertes, an estimable bird portraitist and watercolorist, once remarked of Audubon's grand paintings that "it would be hard to estimate their effect upon me, but I am very sure that they were the most potent influence that was ever exerted on my youthful longings to do justice to the singular beauty of birds." I feel very much the same as Fuertes, and my fascination with the idea of capturing a living, ecstatically colorful creature within the pages of a book was born out of my love for both Audubon and Fuertes.

That the subject of my passion and painting would be trout was determined when, at about the age of nine, I was introduced to fishing by a school friend. On summer days I'd fish for bass in fits of dizzy rapture,

the farm fields alive with the scent of wild rose, or I'd walk down to our town reservoirs in the evening and cast for smallmouth bass with top-water lures. I couldn't explain the desire to capture a large sunfish or pickerel with a live minnow, but I knew these were the settings in which I felt my time was best spent, in the company of lapping waves and the screeching hawk.

The world of the trout stream opened up to me as I began to pursue the more coveted local fish. Trout fishing carried with it a mystique to which I soon became attached. Trout dwelled in flowing water and were harder to see, given the heavy shade of hemlock and swamp maple; they were selective in their feeding, and there were optimum periods in which to catch them. They were the embodiment of what I held to be ideal.

I remember the day I began to paint them. Several years ago, one day in April, my father showed me a magazine article about a rare type of trout found only in eight small ponds in Maine. Called the blueback, it had been pushed to near extinction by man's encroachment on its habi-tat. Instantly intrigued, I searched the library for a volume on trout that was equivalent to Audubon's works on birds. Unable to find any suitable illustrations, I set out to do my own under the instruction of our great bird painters.

The paintings in this book are the fourth set I have completed. Each time I finished painting the seventy or so kinds of trout I wished to dis-play in this book, I noticed an increase in quality from the first to the last. My skills improved with every painting, and I experimented with different mediums and grades of paper. I finally chose watercolor, be-cause I thought it best captured the singular beauty of the fish.

In preparing to paint a trout, I use several devices. Over the years I have acquired some insanely hard-to-find old books written before trout were tampered with on a large scale, before they were decimated or hy-bridized. These descriptions are detailed, since they predate the color photograph. It is from such descriptions that I painted extinct species, like the yellowfin cutthroat, and I also use them to confirm photographs that friends and I have taken of specific fish. But the single most impor-tant source for these paintings is, of course, the color photograph. This is even more valuable than the actual specimen, because the brightness and the color of the fish fade shortly after it's removed from the water. The photos I've used were mostly of fish that were caught and released. By now I have covered thousands of miles in search of trout to photo-graph. In the case of the blueback, for example, my color photos are the only ones I've seen. I wouldn't be surprised if the same blueback I painted for this book is still swimming in Black Pond in Aroostook County, Maine.

Having seen several thousand trout and painted hundreds of them, I have found that each one has its own personality. By that I don't mean simply that every type, strain, form, variety, species, or subspecies is different, but that every *individual* trout is different. Not one trout has a spotting pattern that is duplicated in another. Each fish is distinct and unique. In fact, because of the trout's tendency for intense variation, it is sometimes difficult to identify a fish by species. I've caught the same wild brown trout from a small local stream four times, each time taking a picture before releasing it. At first I didn't realize it was the same fish, but discovered that indeed it was by holding the photos next to one another. I can now identify him streamside by the double spot just to the front left of his dorsal fin. The brown trout shown on page 2 lives in that same stream, in a pool about two miles farther north, and as I write

this he is still alive, though he's become quite wary and I haven't caught him again.

Choosing which specimen to represent a species or strain of trout was quite difficult. The Yellowstone cutthroat, for instance, is brick red when spawning, though at other times of year it ranges from golden yellow to amber. I could easily have done twenty-five paintings for every one in this book, and each would look different. I often chose to represent a male fish in spawning colors, because that's the most colorful. Sometimes I've shown the trout in several stages of life. The brook trout painting is of a fish from a stream about a half-hour from my home; I thought it was the most beautiful brookie I'd ever seen, though of course they're all beautiful.

The trout of North America are as diverse as the regions they inhabit. Their native range extends from the Arctic Circle to the western coast of Mexico, less than one degree from the Tropic of Cancer. All trout are descendants of ocean relatives that permeated rivers and lakes during periods of glacial melt. Two types of trout exist: the true trout and the char. The former normally has dark spots on a light background, sometimes with red spots as well; the latter, light spots on a dark background. Also, char generally require colder waters and are confined to northern latitudes.

I've grouped the trout in this book in five sections: the char; the Apaches, Gilas, and Mexicans; the rainbows, redbands, and goldens; the cutthroats; brown trout and Atlantic salmon. All these are native to North America except the brown trout, which was introduced from Germany's Black Forest in 1883. The char are concentrated in the cold lakes and streams of our north country; the Mexicans, Apaches, and Gilas in the mountains of the southwest of our continent; the rainbows and redbands along the Pacific Coast from Baja California to Alaska. The goldens, ancient ancestors of the redband complex, evolved incredibly brilliant colors on the Kern Plateau in California. The cutthroats are found in the mountain west, and some coexist naturally with rainbows. And the Atlantic salmon call home the coastal rivers from New England through Canada.

All these fish, save the brown trout, existed in North America before the white man came, but things would never be the same after the first hatcheries were established on the East Coast in the late 1800s. The reproduction of trout and careless distribution were nothing short of devastating to native trout. When trout were introduced to a stream, no thought was given to what kind of fish had been in there in the first place—resulting in much hybridization and mixing of species and subspecies. When rainbow trout native to the West Coast were stocked in Colorado mountain streams, they hybridized with the native cutthroat. When lake trout were stocked in Lake Sunapee, they hybridized with the Sunapee, and brown trout introduced to Northeast streams often nudged out native brook trout. Atlantic salmon stocked in the Rangeley Lakes wiped out the blueback, and when brook trout were introduced to the beautiful streams east of the continental divide in Colorado, the greenback cutthroat was wiped out.

Today it is common to catch trout where they don't "belong." Indeed, it is a rare event to catch a trout in its native stream. I've caught my biggest brook trout, some nineteen inches long, in a high mountain lake in Colorado, far from its native New England streams. I catch egg-

yolk-colored brown trout in my hometown creeks, not in the fabled chalk streams of the British Isles or the Black Forest. I've caught beautiful golden trout in the Wind River Range of Wyoming, the other side of the divide from their native Kern Plateau, in the shadow of majestic Mount Whitney. I've caught wild rainbows in the Delaware River in New York State, not the McCloud River in California, where they first swam. I've caught lake trout below Jackson Lake Dam in Wyoming, far from the Great Lakes where they once reigned. I've fished for steelhead in the tributaries of Lake Ontario, not the Deschutes River of Oregon or the Skeena of British Columbia.

Does it bother me that, in proportion to the number of days that I'm fishing, I'm seldom pursuing a trout native to that stream? The idea that not many people really know what they're fishing for pulls at a nerve inside me, as does the fact that anglers in famous tail water streams, where cold water is released from the bottom of a dam, often don't realize that the entire fishery is fabricated. But the largest brown trout to come out of American waters was in Arkansas's Little Red River, which surely never had a trout in it before. We can't really reverse the incredible mixing that we've created in our haste to spread the beauty of the trout, and my hope is, simply, to raise awareness about which fish are native and which are not. The brown trout, though non-native, is one of my favorites; he is wild, however, and after a hundred years in our streams is almost as good as native. And since both my parents are immigrants, I'm just as "foreign" as the brown trout.

A trout in its native stream is a very special thing and should be preserved above all other populations. But while it's of paramount importance to maintain Paiute cutthroats in a desert stream in eastern California, it's no less crucial that we understand "whirling disease"—a fatal affliction among non-native rainbows in Montana's Madison River that could eventually devastate entire fisheries throughout the West. If forced to choose between these two projects, I'd be as confused as a brook trout in the Himalayas. But I do know that people should realize where the amazing variety of our trout comes from. And now that we know non-native fish can devastate native populations, we should stop introducing them.

My purpose in this book is to expose people to the diversity of color, form, and habits of the trout that swim in our waters. In the histories that accompany the paintings, I describe where the trout live and some of the struggles they've endured. As you leaf through the book, I hope you will admire the patterns and forms of the fish as much as I do. I hope they will engage you with their vitality. For me, the trout in its stream is the essence of life—encompassing survival and beauty, death and birth. And I hope my celebration of the trout causes others to feel the same way.

NOTE

The individual who has come closest to making sense of the inexact science of trout classification is Robert J. Behnke, professor of fishery and wildlife biology at Colorado State University. Born in Connecticut, he is world renowned. His most notable work has been devoted to sorting the major evolutionary branching sequences of the western North American trout. My classification choices are mostly based on Behnke's, though I take responsibility for any mistakes.

THE CHAR

Char are a fish of frigid northern waters and are unique in having light spots on a dark body. Arctic char characteristically have a deeply forked tail, as does the lake trout, while brook trout are often called squaretails because they have virtually no fork at all. The name char is derived from the Gaelic word *ceara*, or "blood red," which describes the color of the belly on char as spawning time approaches—anywhere from late summer, in northern latitudes, to early winter. During the summer months, most char are silvery, and their light spots can be undetectable; this is especially the case with sea-run fish.

Arctic char—the most northern of all salmonids—are as hardy as the people who catch them in this treeless land. In the long dark winter, Eskimos cut a hole in a lake through ten feet of ice, fishing with a piece of seal meat on an ivory hook. In summer, when the rivers run free, they catch them in nets made of musk-ox or caribou sinew.

Carolus Linnaeus was first to classify the Arctic char in 1758, from specimens collected in the Swedish Lapland. He named it *Salmo alpinus*, or "salmon of the Alps." The Arctic char and its subspecies (Greenland, blueback, Baffin, Sunapee, Quebec red, Lake Hazen, and long-finned) differ from other char and trout by having a cross section that's more rounded than oval; it's more hot-dog-shaped, so to speak, and also more elongated. Its range is circumpolar, from about the forty-fifth parallel to the eighty-second: from the Bering Sea to the Northwest Territories and from the Hudson Bay to Labrador; from Greenland to Iceland and from Lapland to Siberia. Some of the largest specimens come from the Tree River, emptying into Coronation Gulf of the Northwest Territories; the world rod-and-line record caught here weighed thirty-two pounds.

Arctic char have evolved to withstand the coldest and harshest of conditions, which have made for unique and complex migration and feeding habits. On the Kent Peninsula of the Canadian Arctic, just south of Victoria Island, is a population of char that winters in freshwater lakes and feeds only two months out of the year. Once the outlet stream is free of ice in the spring, the char migrate to the sea and take advantage of the burst of marine life brought on by nearly constant daylight and warmer water temperatures. In August they return to the lake, where they remain nearly motionless until the following spring. Moreover, a fraction of the char, instead of descending to the sea to feed, ascend the inlet of the lake to spawn—and therefore go without feeding for nearly two years. Constrained by such conditions, Arctic char spawn only every three to four years and grow slowly. Their lifespan, however, is surprisingly large: an average fifteen years, with a few fish living as long as thirty. Char with access to the sea can grow large despite the limited feeding period, but landlocked fish are often stunted by lack of food and might never exceed five or six inches in length.

For now the char of the high Arctic are undisturbed by humans and can grow in their dismal solitude, hidden from view by sea and lake ice, to whatever limits their world has created.

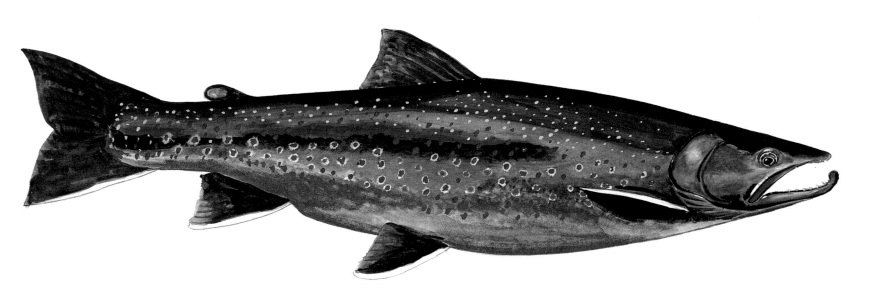

ARCTIC CHAR

Salvelinus alpinus alpinus

Differing little if at all from the Arctic char, the Greenland char was first described as a separate species in 1780, by Fabricius in *Fauna Greenlandica*. The *Salvelinus alpinus stagnalis* pictured is in the condition in which it would appear straight from the ocean. As spawning time approaches, the male develops a strong curved jaw (or kype) and brilliant deep reds on the ventral surfaces. The Arctic char is shown in full spawning dress.

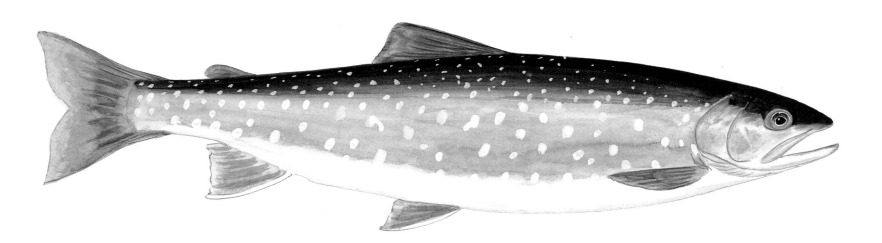

GREENLAND CHAR

Salvelinus alpinus stagnalis

On the tenth of October or so, little bluebacks would come to their selected tributaries of Rangeley Lake to spawn. To the local Mainers in towns like Oquossoc, the blueback was somewhat of a mystery. Spending the rest of the year feeding on zooplankton and small crustaceans in the coldest depths of the lake, these little blue fish were seen only when they came to perform this annual ritual for two weeks in the fall. Early accounts of the spawning runs are astounding. In 1874, an article in *Forest and Stream* magazine noted, "The tributaries are thronged with myriads of this exquisite fish. The waters of the streams are actually filled with this crowding, springing multitude, gathering as do smelts and alewives, to deposit their spawn."

Native only to Maine, this little char was first brought to scientific attention by Dr. Charles Girard at a meeting of the Boston Society of Natural History in 1852 and officially named a new species in 1854 (*Salmo oquassa*, after the town of Oquossoc on its native lake). An 1869 law protected the trout and salmon of Maine with a closed season from October through January, but the blueback was exempt because it was such an important and prolific food source. In relentless harvests, the people of Rangeley smoked, salted, or dried the blueback to be eaten in the off-season or shipped as surplus to New York City's Fulton Fish Market.

More disastrously, in the mid-1870s both Atlantic salmon and smelt were introduced; the smelt competed for food, and the salmon preyed on the blueback itself. A law protecting the fish was passed in 1899, but as William Converse Kendall writes in *The Trout and Charrs of New England* (1914), "The stable door was not locked until after the horse had been stolen."

Kendall had optimistically predicted that "careful research would reveal the blueback in other northern Maine waters." Sure enough, in 1948 an unknown fish caught in Pushineer Pond in Aroostook County was identified as a genuine blueback. Others were subsequently found in Penobscot Lake in Somerset County; Big Reed Pond, Rainbow Lake, and Wadleigh Pond in Piscataquis County; and Black Lake, Deboulie Lake, and Gardner Lake, also in Aroostook County.

You can catch bluebacks today. In spring they will take dry flies when the lake surface is cold, and in evenings in early summer they'll occasionally rise to take that giant green drake mayfly the North Country is famous for. I caught one in Black Lake on a sinking fly line in perhaps thirty-five feet of water. Toward evening it hit my black ghost streamer with vigor and fought very well. At first I thought it was a large brookie, but then recognized him as I cradled his life in my hands. Photographing and releasing this rare jewel is one of the most cherished memories of my time in those Maine woods.

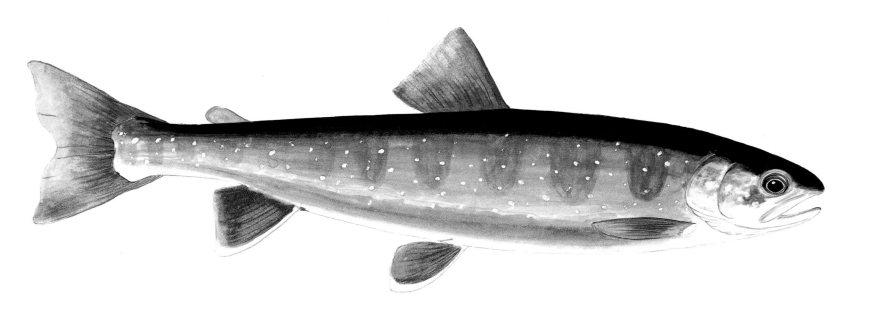

BLUEBACK TROUT

Salvelinus alpinus oquassa

Dr. Günther first described this far northern char of Baffin Island as *Salmo naresi* in 1877. Nares trout, as it is also called, is similar to the blue-back trout in size and color, and it too is a subspecies of the Arctic char. Little else is known about the Nares trout.

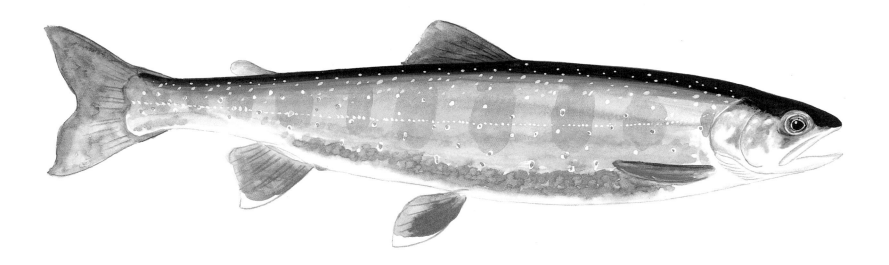

BAFFIN CHAR

Salvelinus alpinus naresi

Aureolus, Latin for "golden," describes the sheen of this rare New England char in the water. Known variously as the white trout, golden char, and Sunapee trout, it went wholly unnoticed until the second half of the nineteenth century. Why this char had been overlooked in such a popular fishing lake as Sunapee in the green rolling New Hampshire hills is uncertain. Local fishermen might not have distinguished it from the brook trout, which was also native to the lake; also, the Sunapee might originally have been too small a fish to take an angler's line, and therefore was never seen. But when smelt were introduced to Lake Sunapee in the late 1860s these fish gained recognition as they soon attained weights of over eight pounds.

Word of this "new fish" spread, and the lake became a mecca for New York City anglers. In the summer in Lake Sunapee, the trout took to the depths and was quite silver in color, leading to the local predilection for the name white trout. As autumn approached, however, they went through a grand transformation into an elegantly gilded creature. Dr. John D. Quackenbos, whose name is synonymous with this fish, described them beautifully in *The Geological Ancestors of the Brook Trout* (1916): "As the October pairing time approaches, the Sunapee fish becomes richly illuminated with the flushes of its maturing passion. The steel-green mantle of the back and shoulders now seems to dissolve into a veil of amethyst, through which the daffodil spots of mid-summer gleam out in points of flame, while below the lateral line, all is dazzling orange. The fins catch the hues of adjacent parts, and the pectoral, ventral, anal, and lower lobe of the caudal are marked in lustrous white."

In the early twentieth century, introduced lake trout began competing with the Sunapee for food—both were fond of smelt—and preying on juvenile Sunapees. Most detrimentally, the newcomers hybridized with the Sunapee by competing for room on the same rocky shoals. Today, no pure form of Sunapee likely exists in the lake, though you can still catch these hybrids. The only pure native population is found in Floods Pond, the public water supply for the city of Bangor, Maine. These trout spawn on a shoal in mid- to late October and feed on smelt, as the char of Lake Sunapee once did, under the careful protection of the Maine Department of Wildlife. The population remains healthy, though fluctuating water demands could threaten the success of their spawning. Growing to about twenty-four inches and a weight of three pounds, they are quite streamlined, rounded, and slender, which is typical of most char.

As for Quackenbos, his ghost likely resides by the banks of Floods Pond, where he keeps a vigil on what's left of his beloved golden char.

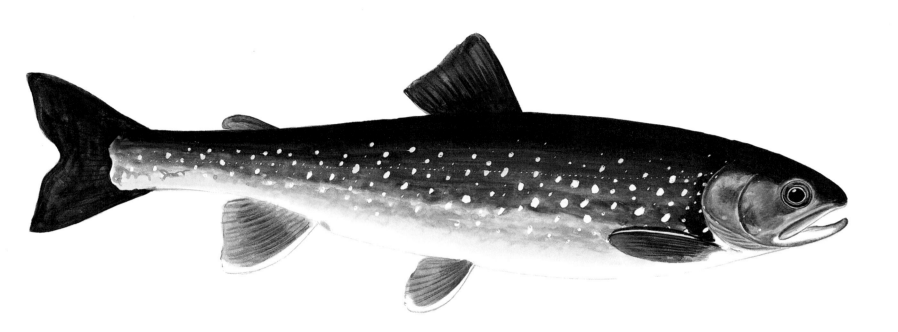

SUNAPEE TROUT

Salvelinus alpinus aureolus

QUEBEC RED TROUT

This Marston's or red trout of Canada was described as a separate species, *Salmo marstoni*, in 1893 by Professor Samuel Garman. The specimens he examined were from Lac de Mabre, in the province of Quebec. They're also found in the 3,700-square-mile Laurentides Park and on the Gaspé Peninsula, where they inhabit perhaps a hundred different deep-water lakes. Though similar to the blueback and Sunapee, they differ in having a longer jaw, better-defined teeth, a more deeply notched tail, and a darker red at spawning time.

Brook trout inhabit all the lakes in which red trout reside, the latter occupying the deepest water while the former takes to the shallows.

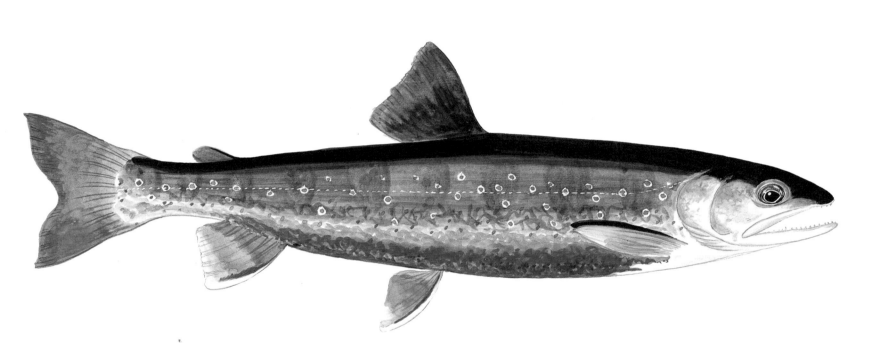

QUEBEC RED TROUT

Salvelinus alpinus marstoni

LAKE HAZEN CHAR

To name this char of the high Arctic after a star is fitting, considering that its home is cloaked in darkness half the year. Arcturus, "watcher of the bear," is one of the brightest stars in the sky and resembles the brilliant spots on the steel blue sides of this northernmost member of the trout family. Lake Hazen on Ellesmere Island, where Admiral Robert Peary collected these char on his expedition to the North Pole, is north of the eightieth parallel, and its surface can remain frozen for years at a time.

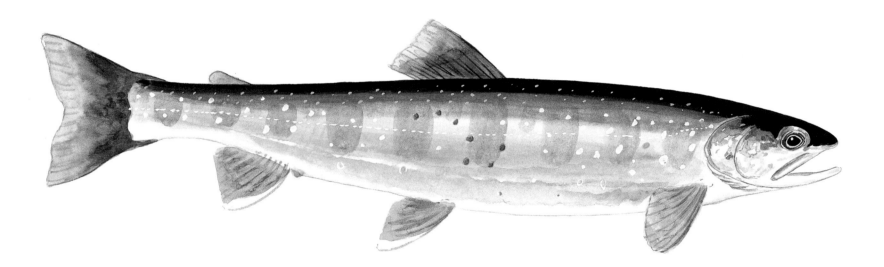

LAKE HAZEN CHAR

Salvelinus alpinus arcturus

LONG-FINNED CHAR

Alipes, Latin for "wing-footed," enchantingly describes the distinguishing characteristic of this fish, whose fins are markedly larger than those of any other char and lend the appearance of flight. Its pectoral fins reach more than halfway to the ventrals, and the dorsal is twice as high as it is wide. One wonders what selective element led to the development of such a peculiarly beautiful fish, which is found only in the high Arctic lakes of Greenland and the Boothia Peninsula. Perhaps they use their long fins as runners on the snow, propelling themselves from one icebound lake to another.

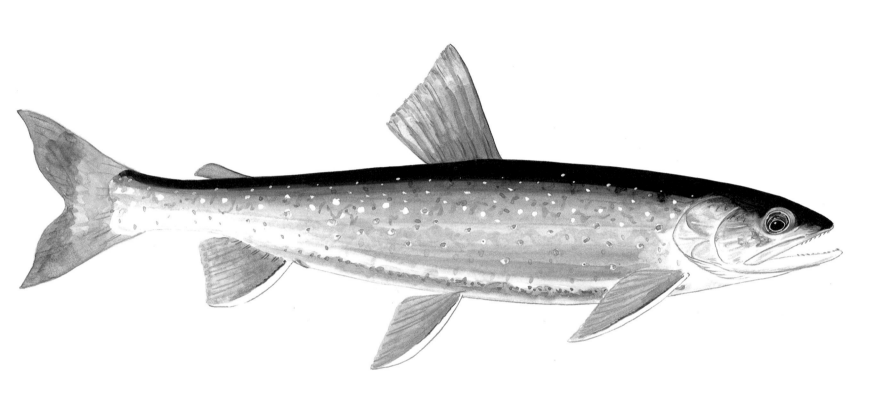

LONG-FINNED CHAR

Salvelinus alpinus alipes

I have learned many lessons from the brook trout—the only char native to my home state of Connecticut—and I hold it in the highest regard. I can walk from the roadside down a wooded hollow to a brook so small that most would not even think to fish it. Here, with a bit of imagination, I can be instantly transported to any place on earth.

From Maine to Minnesota, from Hudson Bay to the mountains of Georgia and Alabama, the brookies have a place to call home. They spawn from September in the north to December in the south, their hormones triggered by changing light and water temperature. Few creatures are more stunning than the brook trout in full spawning dress. Its back is olive to steel blue, cut with golden worm-like markings, fading to more shades of scarlet and vermilion than an autumn sugar maple. Most striking are those crimson spots with halos of violet blue that dazzle the eye in a crazy dimensional illusion.

Brook trout are great survivors, able to endure harsh winters and find cold springs in which to survive the hot summers. They can live in the tiniest of streams, but given room and food, they will expand and adapt to conquer their new environs.

Keep in mind that the largest brookies aren't always the best. But if it's big fish you're looking for, you must go north. The fourteen-pound world record was caught in the Nipigon River, which flows into Lake Superior. For native trophy fish, however, the best water today is Labrador's Goose Bay and, more specifically, Minipi Lake. Equally large non-native trout are frequently caught in Patagonia. I've landed my largest brookies in high mountain lakes in Colorado and Wyoming—but for now, the serenity afforded by the small streams where I grew up is more than enough for me.

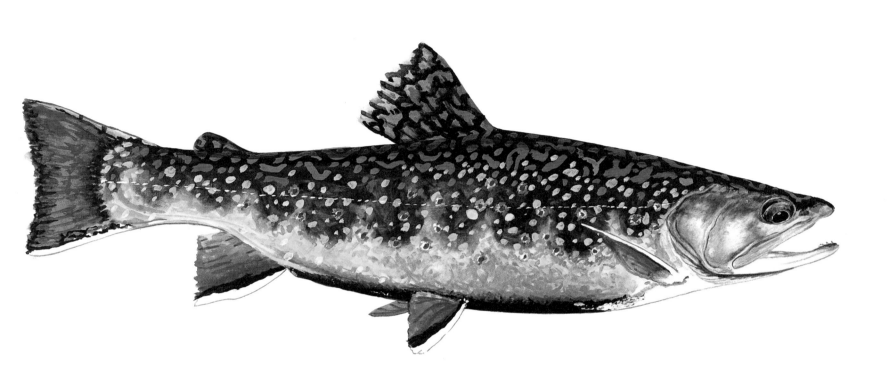

BROOK TROUT

Salvelinus fontinalis fontinalis

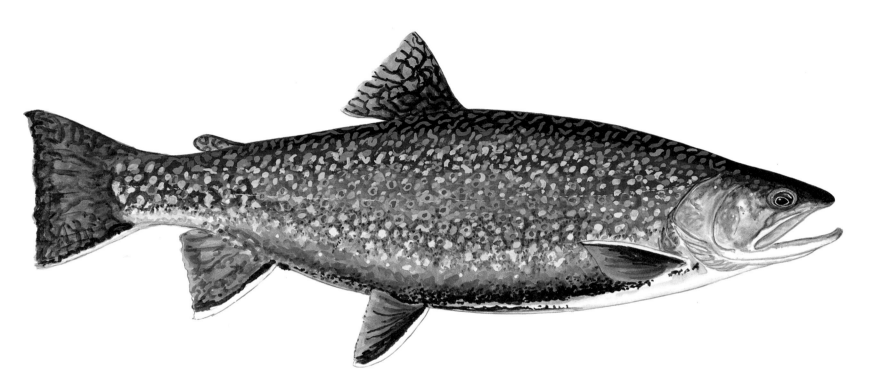

LABRADOR BROOK TROUT

Salvelinus fontinalis fontinalis

SILVER TROUT (extinct)

At the foot of Mount Monadnock, in the village of Dublin, New Hampshire, is a deep pond that once held a peculiar type of trout. Local legend holds that the pond was created when the giant cone of a mountain was thrust from the ground. No streams feed the pond, just cold springs that bubble from its depths.

The silver trout, as it was called by those few who were aware of its existence, was thought to be a subspecies of brook trout coexisting in Dublin Pond. According to early accounts, the silvers spawned in the same area but two weeks earlier. They closely resembled the average brookie but generally were more slender and lacked the vermiculations, or wavy markings, on the back. As the name suggests, they were usually silver in coloration, with lower fins of vermilion and a few scarlet and yellow spots sprinkled along the lateral surfaces.

In 1884 the famous naturalist Louis Agassiz, who was living and teaching in Harvard, remarked in a letter to the Boston *Journal* that the silver trout was "specifically distinct." In 1885, Samuel Garman of the Museum of Comparative Zoology agreed, and he dubbed it *Salmo agassizi* in honor of his colleague. Until then, the silvers had received little protection. Clever fisherman called them lake or brook trout, depending on which season was open, and they were taken in sufficient numbers at spawning to have been "fed by the bushel to the hogs." What probably contributed most to their eventual extinction was the common hatchery brook trout introduced to supplement dwindling native populations. The natives had evolved to coexist with the silver trout without interbreeding; they filled separate niches in the same lake. The stocked brook trout, however, had a slightly different genetic history, and by the early 1900s the silvers were hybridized out of existence.

On a recent summer trek to the White Mountains, I made a pilgrimage to Dublin, where the image of Mount Monadnock can still be seen in the crystal waters of the pond. And if you close your eyes as the sun sets over the peak, you can picture the reflections of thousands of silver trout dancing in a bygone era.

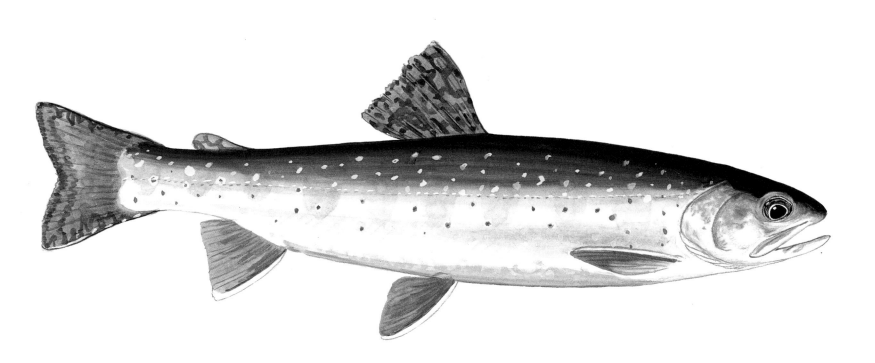

SILVER TROUT

Salvelinus fontinalis agassizi

AURORA TROUT

The aurora or dawn char, so named because its rose colors fuse like those of the rising sun, was first discovered in White Pine Lake in Ontario, where it is native to three lakes. Like the silver, it's considered a subspecies of the brook trout—and has been hybridized nearly to extinction. A program to reproduce aurora char in a local hatchery was begun in 1955, to preserve them from both hybridization and acid rain. Though the brood stock isn't necessarily pure, it is hoped to be, and the fish have been introduced to four area lakes.

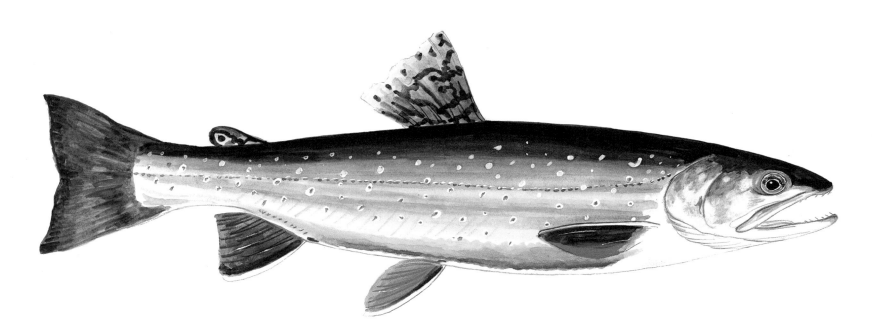

AURORA TROUT

Salvelinus fontinalis timgamiensis

The Algonquian tribes called these legendary fish *namaycush*, or "denizens of the deep," five- to six-foot monsters finning in the shallows at ice-out. These giants of the salmonid family—with some specimens weighing up to 125 pounds, making it the largest trout in North America—were accordingly named *Salmo namaycush* in 1792 by a German doctor named J. Walbaum.

As the common name suggests, these char are found almost exclusively in lakes, although some arctic populations spend their lives in streams. Its vast native range covers Canada and the northern United States. Such wide distribution has given rise to many variations in size, color, and form from which dozens of local names have evolved—from togue, silver laker, or lunge in New England to the mackinaw in the Great Lakes. Lake Superior alone has several strains—half-breeds, humpers, paperbellies, bankers, yellowfins, redfins, sand trout, siscowets, and fats. Much of the seemingly insignificant but crucial genetic diversity of such wonderful types has been spoiled by overfishing and the introduction of hatchery lake trout. Most devastating of all, however, was the invasion of the sea lamprey when the Great Lakes were made accessible to international shipping vessels by the St. Lawrence Seaway.

Lake trout prefer a diet of smelt, alewives, and ciscoes. Their large mouths, neatly designed to handle all big meals, have no doubt enhanced their reputation as being "as omnivorous as codfish." This is borne out by Kendall's description of their diet in *The Trout and Charrs of New England*: "Among the articles which have been found in their stomachs may be mentioned an open jack-knife, seven inches long, which had been lost by a fisherman a year before at a locality thirty miles distant, tin cans, rags, raw potatoes, chicken and ham bones, salt pork, corn cobs, spoons, silver dollars, a watch and chain, and in one instance a piece of tarred rope two feet long. In the spring wild pigeons were often found in their stomachs. It is thought that these birds frequently became bewildered in their flight over the lakes, settle on the water, and become the prey of the trout."

In summer they occupy the coldest depths. Once the surface temperature of the lake cools in autumn, they prepare to spawn on gravel bars and shoals. A habit peculiar to all lake trout is that they spawn at night, concealed from any predator whose night vision is less than acute.

The largest lakers today come from the grand lakes of the Northwest Territories and central Canada—Great Slave, Great Bear, and Athabaska—where fish up to sixty pounds are still caught by jigging or trolling with spinning or casting gear in deep water. Upon bringing one of these leviathans to the surface, you discover why they were so revered by the local inhabitants.

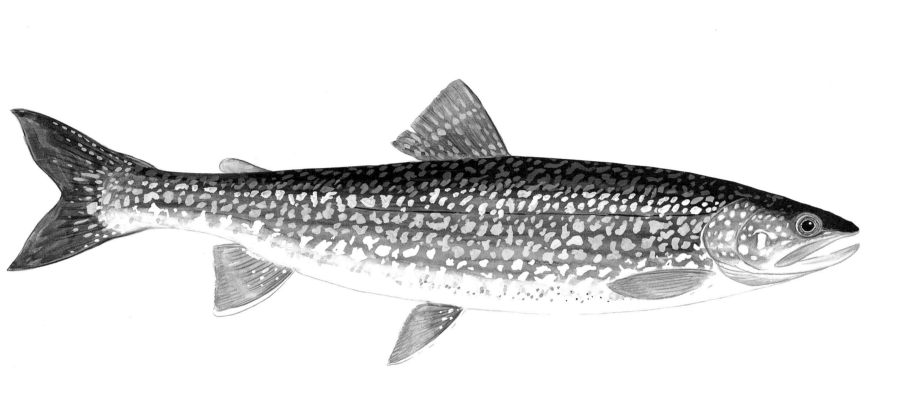

LAKE TROUT

Salvelinus namaycush namaycush

SISCOWET LAKE TROUT

This is the big boy whose kingdom is Lake Superior, in terms of surface area the world's largest freshwater lake. Though similar in appearance to the lake trout, the siscowet has a fatter body, thicker skin, and much higher body fat—all adaptations for living in the deepest and coldest water of the lake. They occupy depths of up to six hundred feet, and have been known to spawn in three hundred feet of water.

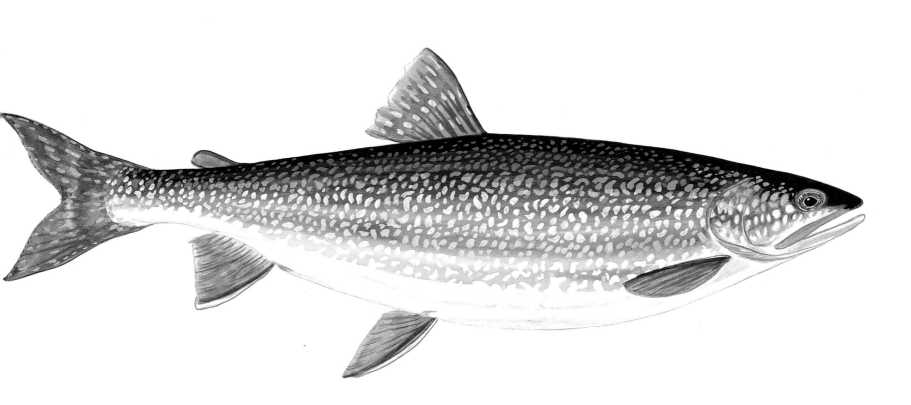

SISCOWET LAKE TROUT

Salvelinus namaycush siscowet

HUMPER LAKE TROUT

This is another of the many native forms of lake trout from Lake Superior. At one time, on the Canadian shore, there are said to have been sixty or so distinct populations of lakers, each spawning on different gravel shoals at different depths and under different conditions. I have chosen to display this particular type because of its wonderfully unusual coloration, large fins, and generally unique appearance. The golden spots contrast so highly with the dark black body that they appear to be holes right through the flesh itself. These fish live on remote, rocky humps in up to a hundred feet of water; hence fisherman call them humpers. Superior is the only Great Lake left with healthy, reproducing native populations of lake trout.

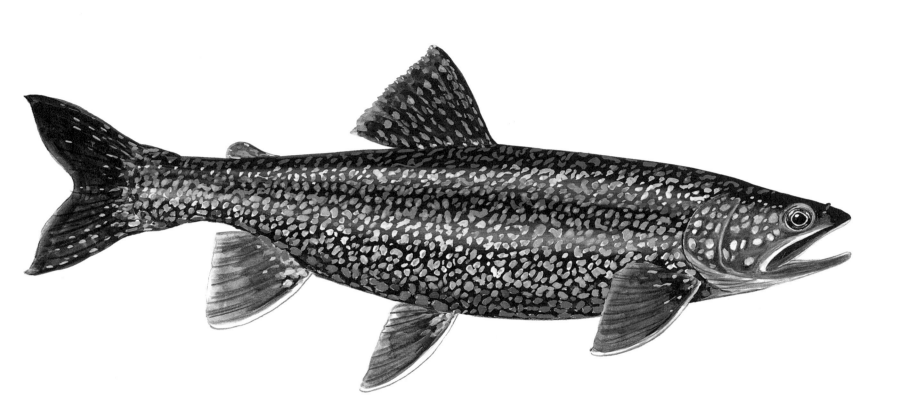

H U M P E R L A K E T R O U T

Salvelinus namaycush namaycush

In 1978, the bull trout was declared a separate species, *Salmo confluentus*, but until then was often confused with the Dolly Varden. Though the two can be difficult to tell apart, the bull trout's cross section is more hot-dog-shaped than oval, and it has a longer, flatter head and a knob of flesh on the tip of the lower jaw. Its beady eyes and broad head give it a somewhat threatening appearance that has lead to the common name of bull trout. These trout are native to Kootenay Lake in British Columbia; to Priest and Pend Oreille lakes in Idaho; and, in Montana, to Flathead Lake and the Bitterroot, Big Blackfoot, Clark Fork, and Swan rivers and headwaters. Though scarce in Nevada, they still persist in some streams of Elko County, in the northeastern part of the state.

Bull trout can attain weights of thirty pounds on a diet of Rocky Mountain whitefish or kokanee salmon, a landlocked form of the sockeye salmon. Though primarily piscivorous, young bull trout will take dry flies on a lake or stream. The world record—originally thought to have been a Dolly Varden—was caught in Lake Pend Oreille in 1949 and weighed thirty-two pounds. This trout might look like a formidable predator, but like all native fish is vulnerable to competition from introduced species (for example, the Kamloops rainbow, another fish eater).

In Latin, *confluentia* means "a flowing together." Here in the coldest and cleanest mountain streams of the Northwest, quietly fishing for westslope cutthroats, you may be surprised by the sudden capture of one of these torpedoes gliding masterfully at the end of your line, deftly spreading the hydrofoils of its fins.

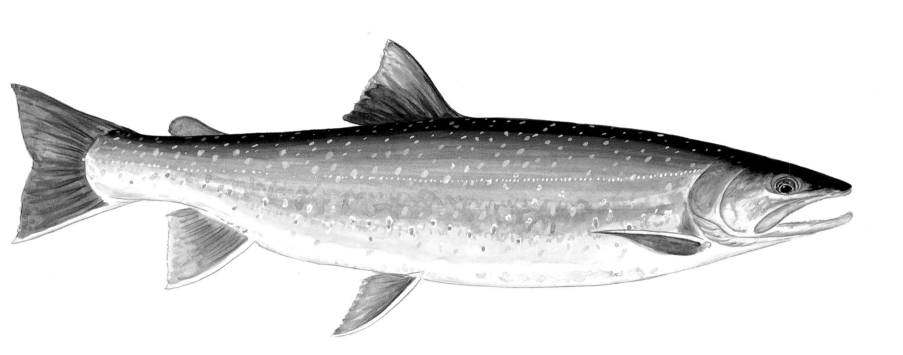

BULL TROUT

Salvelinus confluentus confluentus

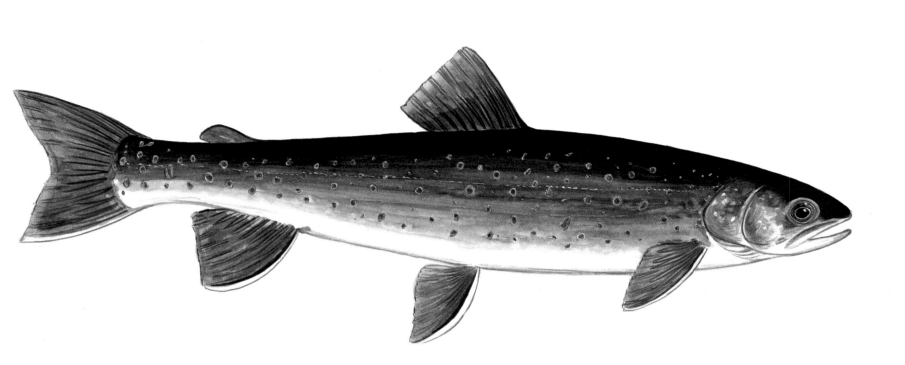

STREAM BULL TROUT

Salvelinus confluentus confluentus

SOUTHERN DOLLY VARDEN TROUT
NORTHERN DOLLY VARDEN TROUT
SPAWNING NORTHERN DOLLY VARDEN TROUT

This western char was named after a character in Dickens's novel *Barnaby Rudge*. Dolly Varden, wrote Dickens, was "the very impersonation of good-humor and blooming beauty," and apparently some angler who'd read the novel noted her resemblance to this beautiful fish. There are said to be two strains: the southern, ranging from Puget Sound to the Alaska Peninsula, and the northern, from the Alaska Peninsula to the Mackenzie River. The two differ little if at all in appearance. I have presented paintings of a southern Dolly from a small stream, and northern Dollies both fresh from the sea and in spawning color.

In 1921, the United States Bureau of Fisheries placed a bounty on Dolly Vardens because they were thought to prey on the eggs of spawning fish. Two to five cents were paid per tail, and as many as six million were killed. By 1939, however, careful examination revealed that many of the tails acquired were from rainbows and coho salmon, the very fish that were purportedly being protected. The bounty was abandoned in 1940, only after the damage had been done. And in fact Dolly Vardens are actually very helpful. They swim in great numbers behind the salmon and rainbows at spawning time to feed on loose and drifting eggs, which if left to fester would contaminate healthy eggs.

The Dolly itself spawns in its natal streams in the late fall. Forms close to the arctic spend their winters in warmer spring-fed lakes, feeding mostly on other fish.

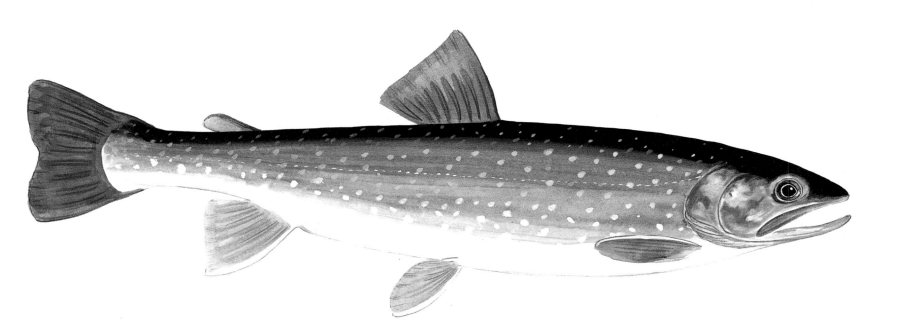

SOUTHERN DOLLY VARDEN TROUT

Salvelinus malma malma

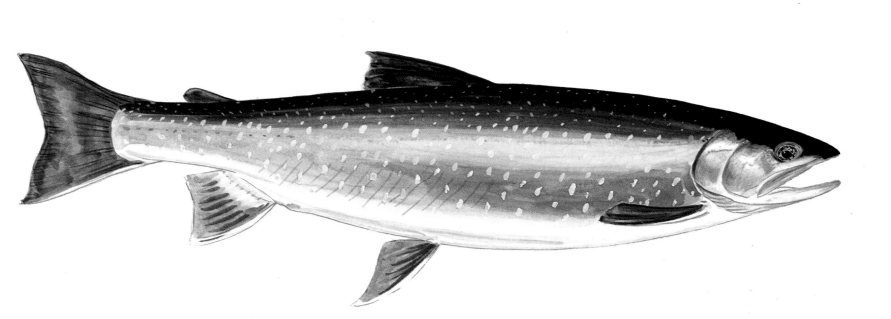

NORTHERN DOLLY VARDEN TROUT

Salvelinus malma malma

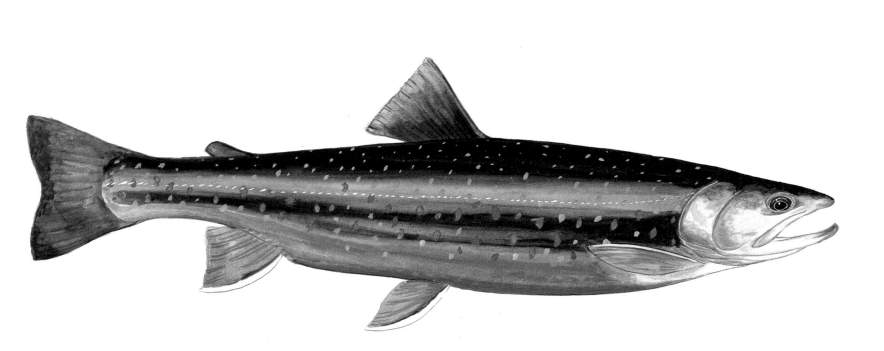

SPAWNING NORTHERN DOLLY VARDEN TROUT

Salvelinus malma malma

APACHE, GILA, AND MEXICAN TROUT

These little-known trout form an interesting trio. They are found in the Southwestern United States and in western Mexico in streams draining into the Gulf of California, and are thought to be related to coastal rainbows. The Apaches, Gilas, and Mexican goldens are the most diverged from the rainbow, while those of the headwaters of the Río del Presidio, which hold the distinction of the southernmost trout in the world, are the most rainbow-like.

In 1871, President Grant deeded more than 1.6 million acres in the White Mountains of Arizona to the Apache, who regarded this fish as sacred. Off the reservation, however, this was not the case, and in the past century overfishing and hybridization have driven the Apache trout to the brink of extinction. In 1967, it was listed under the Endangered Species Act. By 1975, because of successful management by state biologists and members of the Apache tribe, its status was improved from endangered to threatened.

Though it is impossible to know for sure, the native range of the trout certainly included the White and Black river drainages; the headwaters of the Salt, Little Colorado, and Blue rivers; and most waters in the White Mountains. Today, pure strains exist on Mount Baldy and Mount Ord on the Fort Apache Indian Reservation and in tributaries of the upper East Fork of the White River (such creeks as Upper Diamond, Sun, Moon, Lofer, Cunega, Flash, Squaw, Hurricane, Paradise, Ord, and Upper Bonito) and of the Black River (Soldiers, Boggy, and Bear Wallow creeks).

Fishing at the lower end of these fine creeks, you're bound to catch some non-native but indisputably beautiful wild brown trout. For native Apaches, however, you must go above the natural barriers that have kept introduced species out. If you ever catch one, you'll notice it is different from any other trout. Given the smaller number of vertebrae, the body is far more compressed. The fins are markedly larger; the dorsal, ventral, and anal fins are tipped with ivory; and the adipose is said to be the largest of any trout. A dark spot on either side of the iris gives the eye a banded appearance, and black spots are scattered with a careless hand along the lateral surfaces. In headwater streams above five thousand feet, the Apache trout rarely exceeds fifteen inches. Fish stocked in Christmas Tree and Hurricane lakes grow to four pounds on a diet of aquatic and terrestrial invertebrates.

The Apache tribe has taken good care of its native fish on the reservation. So if you fish in the White Mountains, stop to thank these wardens who, along with their ancestors, have enabled Apache trout to survive beneath the azure skies of Arizona.

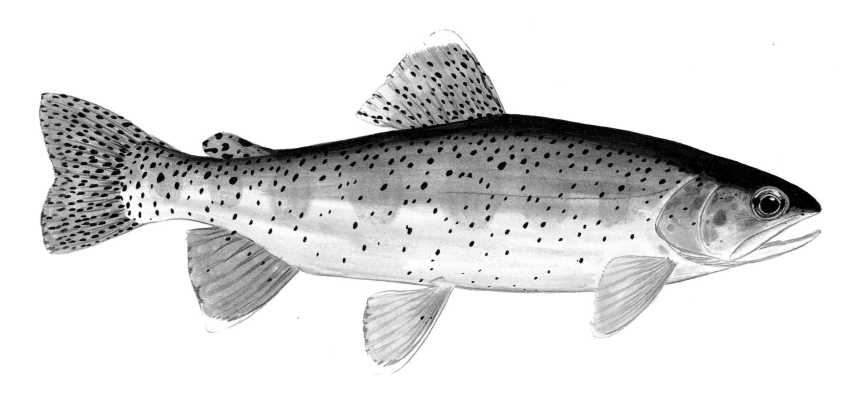

APACHE TROUT

Oncorhynchus gilae apache

Like the Apache, the Gila now lives only in the uppermost of headwater streams. Though these streams are small, the fish grow to surprisingly good size, sometimes twelve or fourteen inches. As with many rainbow relatives, the Gila spawns in spring. It resembles the Apache in general appearance but often has a golden color with splashes of pink along the lateral line; its most distinguishing characteristic is a profusion of smallish spots concentrated toward the tail and on the dorsal surfaces—in all, a beautiful creature, but not one without troubles.

Main Diamond Creek, which fostered the most promising population, was closed to fishing in 1958, on the grim but realistic assumption that only this could save the species. Listed as endangered in 1967, the Gila today is found only in five small streams in New Mexico (Mckenna, Iron, and Spruce creeks in the Gila Wilderness Area, and Main Diamond and South Diamond creeks in the Aldo Leopold Wilderness Area). Because they have remained isolated in these five pockets for some time,
each of these populations of Gila trout is genetically distinct.

In an attempt to extend their limited range, Gilas have been introduced into several previously vacant streams in the Gila National Forest. These efforts were relatively successful, but in 1988 misfortune struck Main Diamond Creek in the form of a severe drought followed by a forest fire and—after 566 Gilas were removed and safely transported to a hatchery—a flood that scoured what was left of the creek, eliminating all the Gilas that remained.

Aldo Leopold, for whom one of the last Gila refuges is named, earned his fame as a nature writer with *The Sand County Almanac* (1949). When he laments the disappearance of the migrating cranes in a marsh now drained and turned to field, he writes, "When we hear his call we hear no mere bird. We hear the trumpet in the orchestra of evolution." The harmony of that orchestra depends every bit as much on the beleaguered Gila.

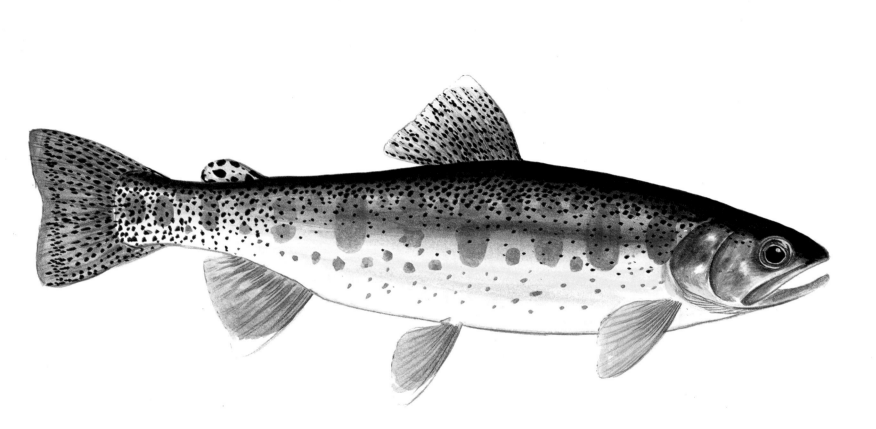

GILA TROUT

Oncorhynchus gilae gilae

RÍO YAQUI TROUT
RÍO SAN LORENZO TROUT
RÍO DEL PRESIDIO TROUT

These fish live in the Sierra Madre of western Mexico and are named for their natal streams. Little else is known of them. The Río Yaqui are thought to be a rainbow strain. Nelson caught fish in the Río San Lorenzo as early as 1898, and it can be assumed these were native since there was little or no stocking at that time. The trout of the Río del Presidio are the southernmost native trout in the world, swimming in streams less than one degree north of the Tropic of Cancer.

Adventurous souls prospecting for Mexican trout will have to search pretty hard. Streams running through areas of human habitation often serve as the town toilet, and when Robert Smith went fishing in 1983, people told him the trout were "*muy poco.*" On the other hand, you might hike up some headwater stream and discover a trout that is new to science.

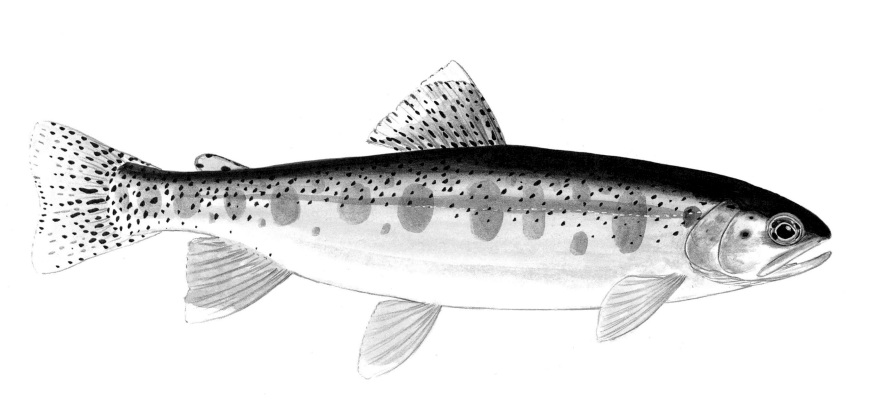

RIO YAQUI TROUT

Oncorhynchus sp.

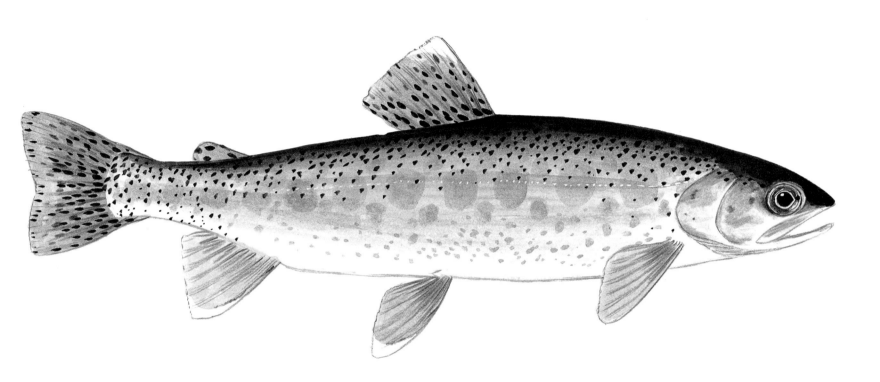

RÍO SAN LORENZO TROUT

Oncorhynchus sp.

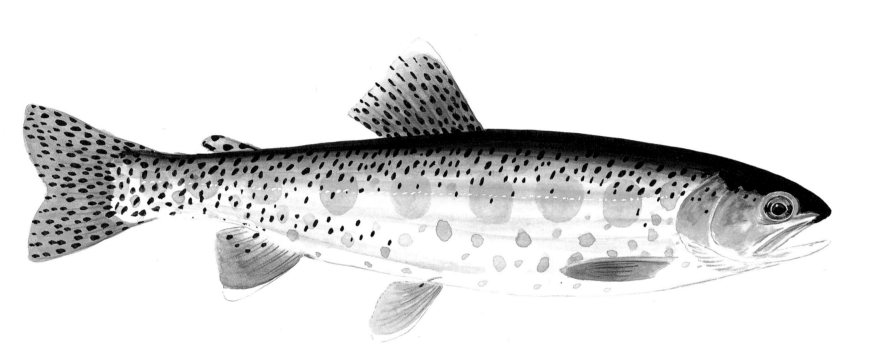

RÍO DEL PRESIDIO TROUT

Oncorhynchus sp.

MEXICAN GOLDEN TROUT

The Mexican golden is found on the west coast of mainland Mexico. First described and illustrated by P. R. Needham and R. Gard in 1959, it was formally named for its hues of *chrysos*, or gold. Thought to be one of the most primitive lineages of western trout, it lives in the headwaters of Río del Fuerte and the tributary rivers Verde, Sinaloa, and Culiacán. These trout are delicate little creatures with orange-rimmed bellies, gold-yellow bodies, and small diffuse irregular spots and parr marks amidst the bluish cast on the back and lateral surfaces.

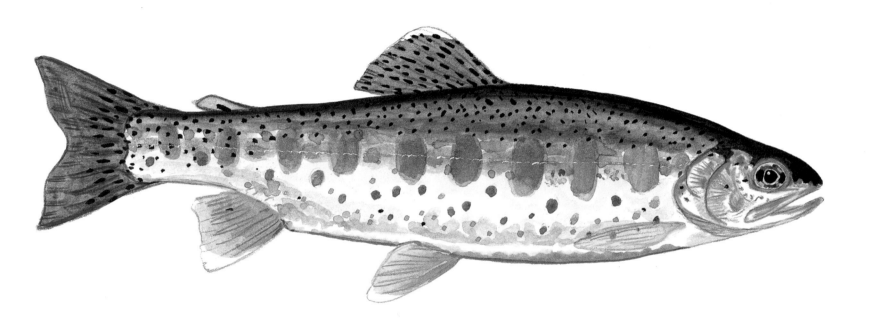

MEXICAN GOLDEN TROUT

Oncorhynchus chrysogaster

RAINBOW, REDBAND, AND GOLDEN TROUT

Rainbows are native to streams of the Pacific Coast, from Kuskokwim River in Alaska to the Río Santo Domingo in Baja California. Anadromous rainbows, those that live in the sea and spawn in rivers, are called steelhead and often coexist with resident coastal rainbows that spend their entire lives in streams. Redbands are a type of rainbow that generally live farther inland and characteristically have smaller scales and more intense coloration. Golden trout are thought to have evolved from the redbands, though they differ significantly enough to be given status as a separate species. It is important to note that the genus name for western trout was recently changed from *Salmo*, which includes brown trout and Atlantic salmon, to *Oncorhynchus*, that of the Pacific salmon. The species name for the rainbow trout, *mykiss*, was given by J. Walbaum in 1792.

One of the first things I observed as a visitor in the new frontier was that everything was big. Alaska boasts Mount McKinley, at over twenty thousand feet the highest peak in North America, as well as Kodiak bears, golden eagles, and enormous moose. I was as displeased to find that the mosquitoes followed this pattern as I was pleased that the native rainbows did too.

Anglers come from around the world to Alaska—famous for its runs of five species of salmon (king, coho, sockeye, chum, and pink), as well as for Dolly Varden, Arctic char, and the largest grayling in the world. But its greatest game fish is arguably the rainbow trout. The rainbows depend on the salmon runs for food. In addition to loose eggs that drift behind the spawning salmon, they feed on the flesh that flakes off after the salmon have died (hence anglers use flies that imitate both eggs and the flesh). Other forage includes insects, clams, small fish, voles, and lemmings.

Characteristically, they have white tips on the ventral and anal fins, vibrant red on the gill covers and flanks, and a profusion of black spots that blanket the sides (giving it the moniker of leopard trout). Alaskan rainbows live an average of eleven years and attain weights of more than fifteen pounds; they spawn in spring at an average age of seven years. Some of the largest are found in Lake Iliamna and the Naknek drainage, which are accessible only by plane. The Kenai River, though, has great rainbow fishing and is only a two-hour drive from Anchorage.

The Kenai runs a turquoise blue, owing to the glacial silt that reflects sunlight. In its flows, below a pod of spawning king salmon, I caught the prize fish of my trip, using fly patterns that imitated their eggs.

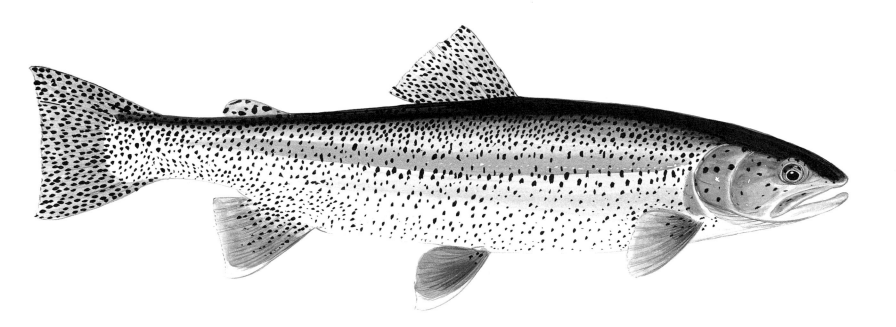

ALASKAN RAINBOW TROUT

Oncorhynchus mykiss mykiss

UPPER KLAMATH LAKE TROUT
OREGON REDBAND TROUT

In 1855, a member of the Pacific Railroad Survey, Dr. Newberry, collected specimens of a new type of trout from the Klamath drainage in southern Oregon and sent them to Dr. Charles Girard, a biologist who named it *Salmo newberri* in his honor. These Oregon redbands live in some of the most arid and unstable environments known to any trout— isolated in pockets of streams with nonexistent flows and temperatures above eighty degrees. The trout of Upper Klamath Lake are slightly differentiated from those of the desert basin streams, having adapted to alkalinity levels lethal to introduced trout, which seldom live long enough to hybridize with the natives. The Upper Klamath Lake trout, therefore, is genetically pure.

Redbands are native to streams in six basins in southern Oregon: the Malheur, Catlow, Chawaucan, Warner Lake, Goose Lake, and Fort Rock. Their appearance varies, but generally they are yellow-orangish on the sides, with distinct parr marks and a sprinkling of black spots.

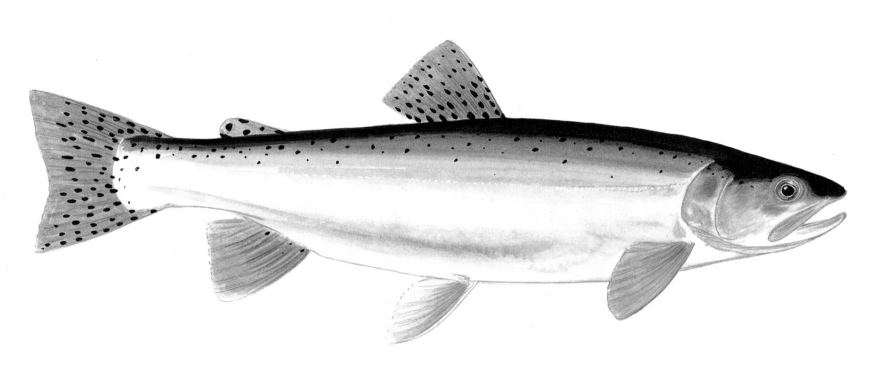

UPPER KLAMATH LAKE TROUT

Oncorhynchus mykiss newberri

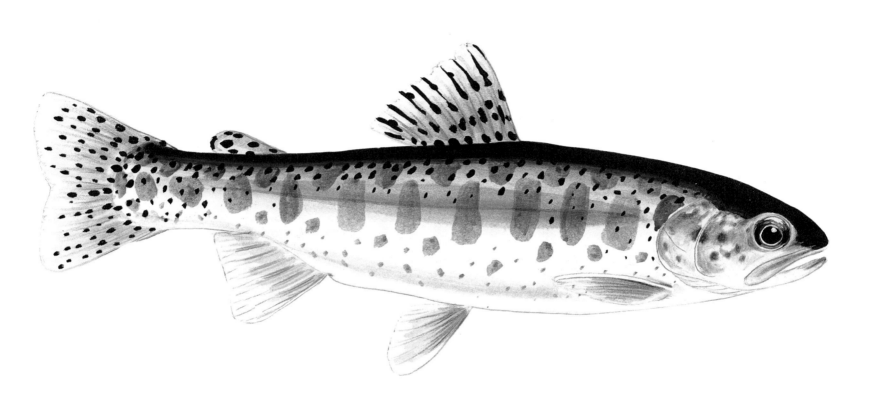

OREGON REDBAND TROUT

Oncorhynchus mykiss newberri

The steelhead is one of the most revered of all game fish. When hooked in a river, it fights as if it were still in the sea, desperate to fulfill the insatiable urge to spawn. Before dams were built on the mighty Columbia River, they migrated more than fourteen hundred miles to spawn in selected gentle flows, where their offspring would have a chance of survival. Now, as with most trout, they are feeling the continuing encroachment of civilization, and native populations up and down the Pacific Coast are becoming increasingly scarce.

The steelhead gets its common name from the steel-blue cast along its head and back, and its poetic subspecies name, a reference to the goddess of the rainbow, describes their tendency to develop an iridescent rosy stripe toward spawning time. Their native range stretches from the Alaska Peninsula to Malibu Creek, California, and in a multitude of these rivers spawning runs from the sea occur during every month of the year. After hatching, steelhead spend the first two or three years feeding in their natal rivers, then undergo what is called "smoltification"—a process that prepares them to endure salt water—and descend to the ocean. After spending one to three years feeding, they're both powerful and determined enough to ascend cascades and falls on their way "home" to spawn. Unlike Pacific salmon, steelhead can survive to spawn a second time, though much less than half usually do. The fish that return to spawn several times can be quite large (the record being forty-two pounds).

Today, good runs of stocked steelhead occur in tributaries of the Great Lakes. For example, the Au Sable—which flows into Lake Michigan—received a shipment of "rainbows" in 1876 from the McCloud River of California, and by accident the majority of the eggs were from steelhead. The fish has also been successfully introduced to tributaries of Lake Ontario, the most popular of which is the Salmon River in Pulaski, New York. Only a five-hour drive from New York City, it has provided a taste of Pacific Coast fishing for eastern anglers.

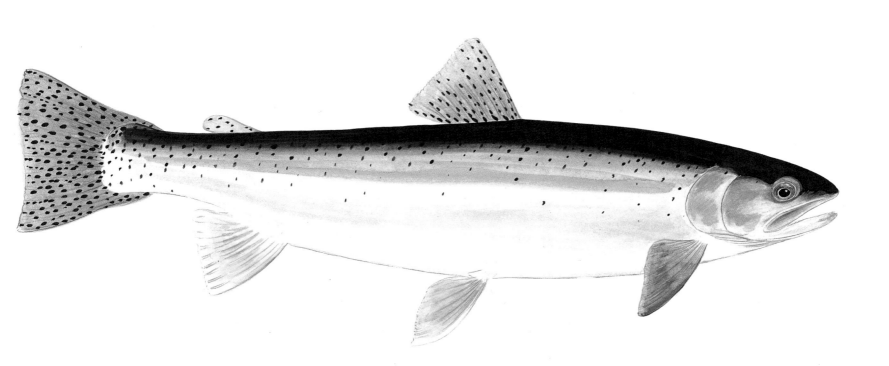

STEELHEAD TROUT

Oncorhynchus mykiss irideus

McCLOUD RIVER RAINBOW TROUT

Trout of this Pacific Coast river have been used most frequently for propagation and stocking purposes, and now are found on every continent of the earth except Antarctica. Their first trip east was in a shipment to Seth Green, the famous fish culturist at the hatchery in Caledonia, New York, in 1878.

Coastal rainbows like these are resident fish but often live among migratory steelhead. The McCloud River trout was given a species name by David Starr Jordan (*Salmo shasta*) but today is considered simply a "generic rainbow."

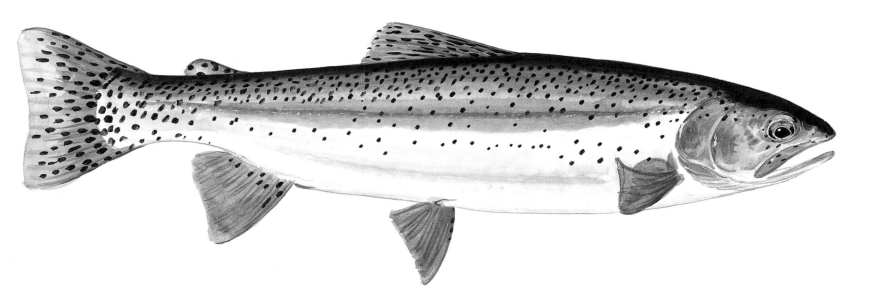

McCLOUD RIVER RAINBOW TROUT

Oncorhynchus mykiss shasta

SHEEPHEAVEN CREEK REDBAND TROUT

At the headwaters of the McCloud River is Sheepheaven Spring—and the creek that bubbles up from here is one of the last refuges of pure redband trout in California. The biologist J. H. Wales made the first report on the small fish from Sheepheaven Creek in 1939. Given their yellow-orange colors and slight cutthroat slash, he couldn't decide whether they were a rainbow, golden, or cutthroat strain.

Sheepheaven Creek is tiny, no wider than six inches in places, and today these fish number only in the hundreds. There is talk of listing them as endangered.

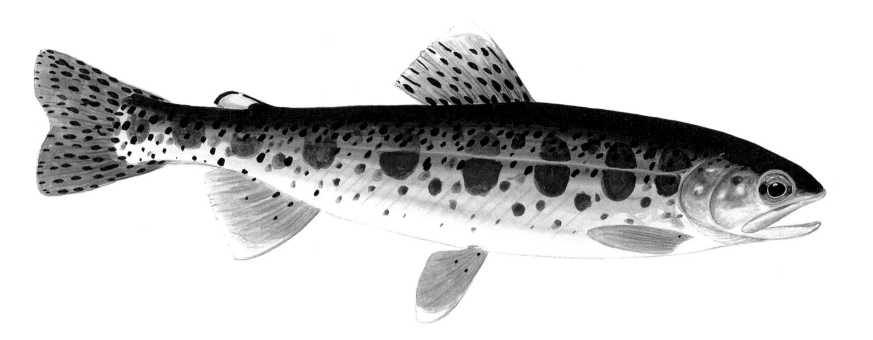

SHEEPHEAVEN CREEK REDBAND TROUT

Oncorhynchus mykiss stonei

COLUMBIA RIVER REDBAND TROUT

This redband is associated with the Columbia River basin, including such rivers as Spokane, Snake, Pend Oreille, and the famous Deschutes, where they're called "redsides." Their coloration can be quite exquisite, with yellows, purples, reds, and greens washed among the distinct black spots and the elliptical parr marks characteristic of juveniles. The fish pictured is typical of small populations isolated in headwater streams.

In 1836, using specimens from the Columbia River, Sir John Richardson named this redband *Salmo gairdneri* in honor of the man who collected them—Dr. Gairdneri, a naturalist who worked for the Hudson's Bay Company.

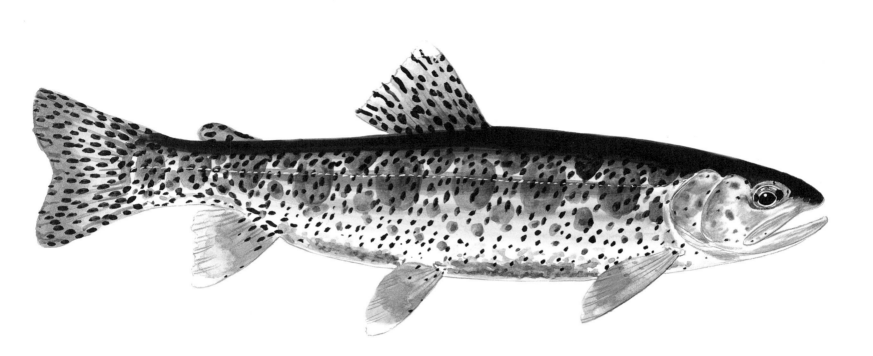

COLUMBIA RIVER REDBAND TROUT

Oncorhynchus mykiss gairdneri

KAMLOOPS TROUT
MOUNTAIN KAMLOOPS TROUT

The Kamloops, a form of the Columbia River redband, attains the largest weight of any rainbow. These voracious predators can grow to fifty pounds on a diet of landlocked sockeye salmon. Their large size has made them very popular with anglers, of course, and they have been stocked extensively outside their native range. The Kamloops was named in 1892 for specimens from Kamloops Lake in British Columbia, where native populations are found in the Fraser River and its tributaries and in the upper Columbia.

The mountain Kamloops differs in having smaller scales, more intense coloration, and a tendency to retain its parr marks into adulthood. The mountain Kamloops trout is native to the Wakleach drainage and other headwater streams of the Fraser and Columbia river systems.

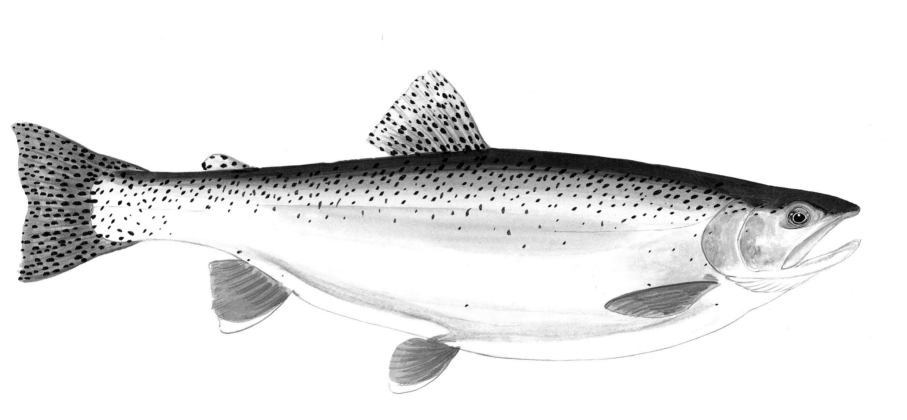

KAMLOOPS TROUT

Oncorhynchus mykiss kamloops

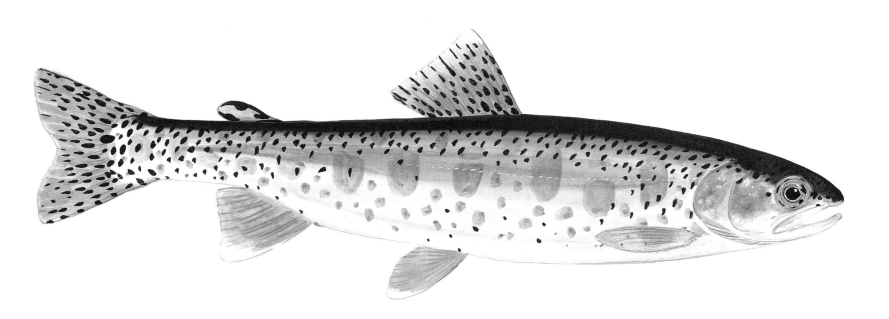

MOUNTAIN KAMLOOPS TROUT

Oncorhynchus mykiss whitchousi

Near Susanville, California, by the desolate Brockman Flat lava beds, lies the vast expanse of Eagle Lake. The water's alkalinity is lethal to most introduced fish, but this native rainbow has evolved over thousands of years to tolerate it; without much possibility of hybridization the rainbows of Eagle Lake have remained genetically pure. Named *Salmo aquilarum* in 1917—*aquila* is Latin for "eagle"—this fish is likely a redband, though it has characteristics of both the rainbow and cutthroat.

As spawning time approached in spring, Eagle Lake trout would ascend small tributaries like Pine Creek, where they would drop their eggs and milt. But spawning on this degraded creek is no longer successful, and during the 1950s this trout was thought to be near extinction. Since then, artificial propagation has supported a population no longer able to reproduce itself. They also have been planted in other Northern California lakes with similar alkalinity.

Fly fishing for the Eagle Lake trout is good near shore from October until around December, when the lake freezes, and after ice-out. When the surface temperature is warm in the summer, these silver beauties take to the depths, where they feed on their forage fish, the tui chub, as they have for thousands of years.

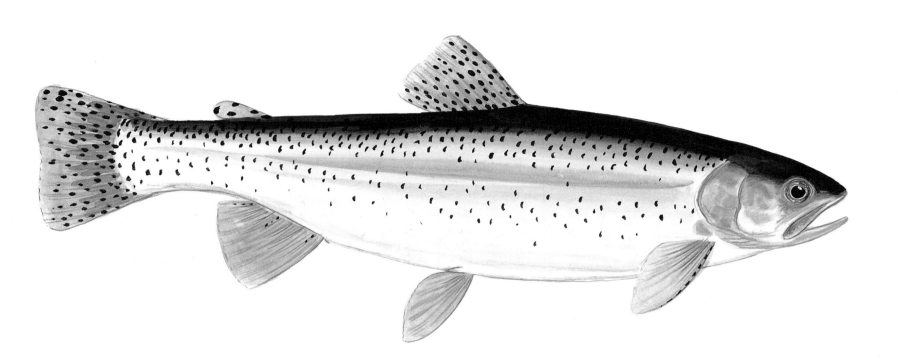

EAGLE LAKE RAINBOW TROUT

Oncorhynchus mykiss aquilarum

In northern Baja California, in the headwaters of the Río Santo Domingo draining west off the Sierra San Pedro Mártir, lives this exquisite coastal rainbow. The first specimens were collected in 1905 by Nelson and sent to Barton Warren Evermann, an eminent fish biologist, who in 1908 classified them as *Salmo nelsoni* in his honor.

They likely migrated up the Santo Domingo from the Pacific during the last glacial melt, when ocean temperatures were cooler. A stronghold of this trout today is La Grulla River tributary, where they were carried over barrier falls from the Santo Domingo during the 1920s. It is the only native trout of the Baja—we can only hope that it will fare better than the California condor, which once reigned in the skies above their streams.

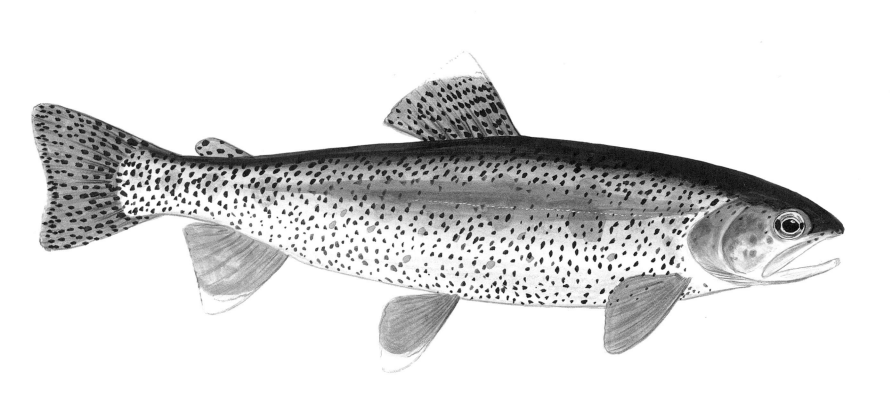

NELSON TROUT

Oncorhynchus mykiss nelsoni

LITTLE KERN RIVER GOLDEN TROUT
VOLCANO CREEK GOLDEN TROUT
SOUTH FORK KERN RIVER GOLDEN TROUT
GILBERT GOLDEN TROUT

Golden trout—thought to have evolved from redbands—are native only to the Kern River drainage in the High Sierras, just south of Mount Whitney, the highest peak in the lower forty-eight states. Isolated in headwater streams as redband ancestors by glaciation and other natural phenomena, they have evolved into unique variations in their respective creeks. Gold prospectors, discovering their favorite color on the flanks of this noble fish, were moved to transplant them into streams throughout the area. The taxonomic species name, *aguabonita*, is Spanish for "pretty water," and the golden trout's vibrant coloration provides good camouflage in gravel-bottomed streams sprinkled with the occasional gold nugget.

The trout of the Little Kern River were named *whitei* by Barton Warren Evermann in 1906, after the novelist and conservationist Stuart Edward White, who persuaded Theodore Roosevelt to ensure the survival of these rare fish. Listed as endangered and subsequently reclassified as threatened, they have made an amazing comeback with the help of federal and state agencies, as well as volunteers from such organizations as Trout Unlimited. This golden is native to such tributary creeks as Deadmans, Wet Meadows, and Upper Soda Spring, but has since been established in new streams.

Evermann named a trout from Volcano Creek *roosevelti*, after the president who put him in charge of studying these fish. These are the most intensely colored of all golden trout, and their distinguishing characteristic is the paucity of spots, most of them around the tail.

The trout of the South Fork of the Kern are slightly less colorful than the Volcano Creek fish and usually have more spots. Though hybridization with rainbows has clouded their genetic integrity, pure specimens still persist in the Mulkey Creek tributary in Tunnel Meadows.

Gilbert goldens are the trout native to the main section of the Kern River, which has mostly been overtaken by rainbows (who might possibly be native themselves). Nevertheless, Gilbert goldens persist above barrier falls in high headwaters, such as Coyote Creek, and are the least dramatically colored of the four strains.

Most goldens on the Kern are no more than ten inches, though you can find larger specimens transplanted outside their native range—for example, in high-elevation lakes in Wyoming's Wind River Range and in

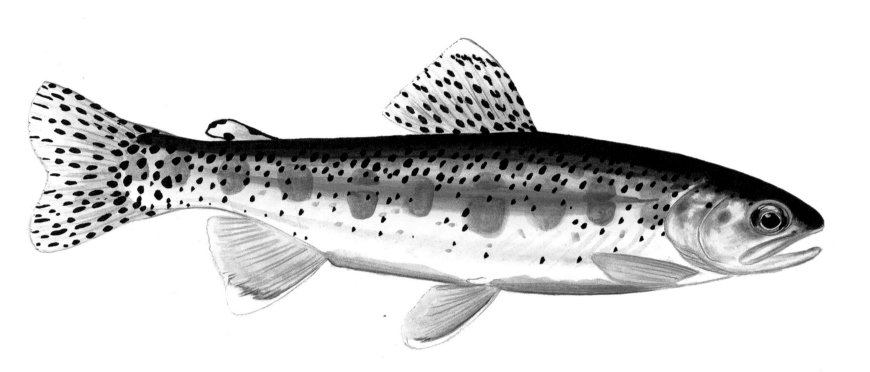

LITTLE KERN RIVER GOLDEN TROUT

Oncorhynchus aguabonita whitei

the Beartooths in Montana. I hiked into the Winds with a friend one summer, up the headwaters of the Green River to Faler Lake, a ten-acre pond above ten thousand feet. There was no trail, and in a lightning storm above treeline we began to wonder whether any golden trout was worth all this. Arriving at the lake, we hid among some large boulders until the storm passed, then walked to the outlet stream and saw throngs of large golden trout spawning—far from their home, but no less beautiful.

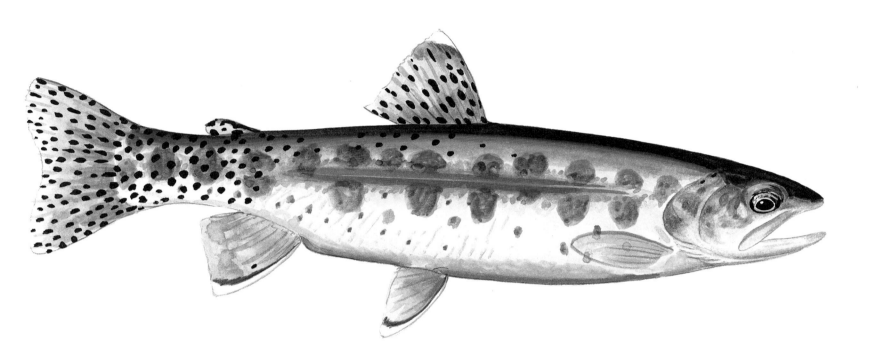

VOLCANO CREEK GOLDEN TROUT

Oncorhynchus aguabonita roosevelti

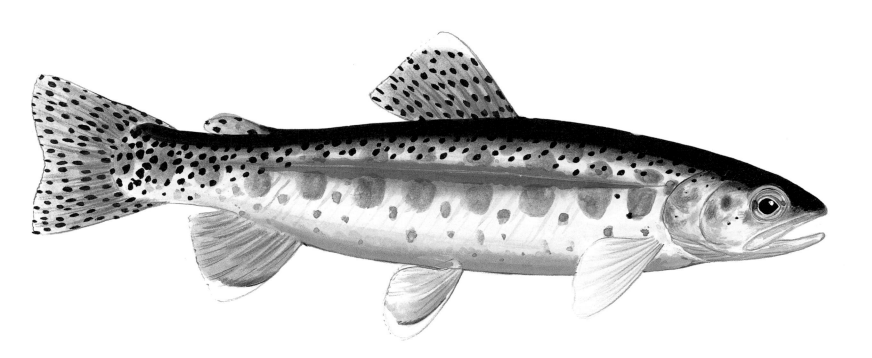

SOUTH FORK KERN RIVER GOLDEN TROUT

Oncorhynchus aguabonita aguabonita

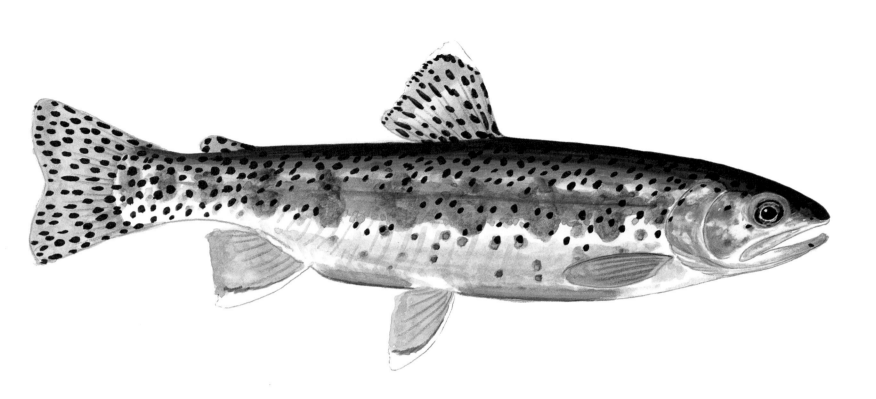

GILBERT GOLDEN TROUT

Oncorhynchus aguabonita gilberti

CUTTHROAT TROUT

Cutthroats are identified by, and named for, the pair of orange-red slashes under the jaw. Native to the West, they overlap somewhat with the range of the rainbow-redband, and spawn in spring. The coastal cutthroat shares tidal waters with coastal rainbows from Northern California to Alaska, and the slash on this fish is often hard to see. The species name, *clarki*, is derived from that of William Clark, who collected specimens with Meriwether Lewis in their expedition of 1805.

COLORADO RIVER CUTTHROAT TROUT
SPAWNING COLORADO RIVER CUTTHROAT TROUT

Once the dominant fish of the upper Colorado and Green River drainages, the Colorado River cutthroat is now relegated to headwater creeks above barrier falls. More brilliantly colored than the cutthroats of the Yellowstone and Bonneville drainages, it resembles the most beautiful of Colorado sunsets.

Roughly twenty pure populations survive in Colorado, as well as a few in headwaters of the Green River in Wyoming and the Escalante in Utah. There has been limited distribution of this trout, but one case is worth noting. In 1931, eggs from Trappers Lake in Colorado were transplanted to the California Sierras in the Williamson Lakes, where the trout remain pure to this day. The population in Trappers Lake, however, has been damaged by the introduction of rainbows.

My quest for the native fish of the Colorado led me beyond the red canyon walls of the Fryingpan River to its headwater lakes. Though it was late July, the trail was still covered with snow, but by nightfall we had navigated to the lowest of the three Fryingpan Lakes, nestled at the base of several peaks. And at the outlet of the highest lake the following brisk morning, I caught a beautiful red-bellied male in spawning dress. His colors resembled our campfire coals of the previous night, and before that brilliance faded I let him go to warm another heart and swim another day.

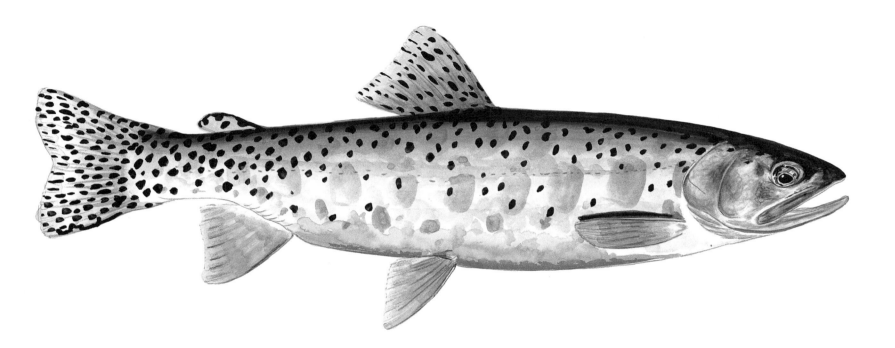

COLORADO RIVER CUTTHROAT TROUT

Oncorhynchus clarki pleuriticus

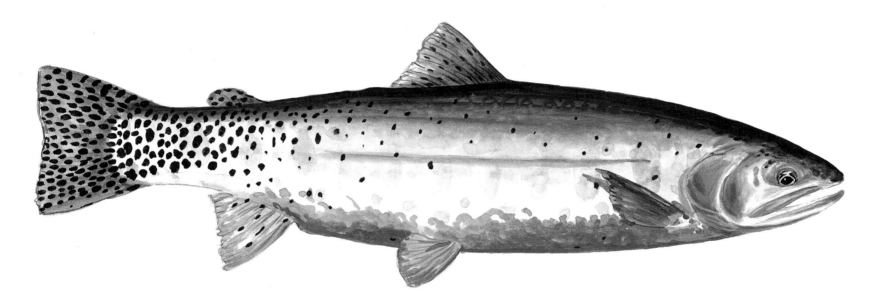

SPAWNING COLORADO RIVER CUTTHROAT TROUT

Oncorhynchus clarki pleuriticus

GREENBACK CUTTHROAT TROUT
JUVENILE GREENBACK CUTTHROAT TROUT

Hordes of people came to Colorado in the 1800s seeking gold. Armed with spears and an abundance of dynamite, they fished the peaceful streams in less than orthodox fashion. The native greenback cutthroat helped feed the settlers of the South Platte and Arkansas drainages, but were overharvested and soon faced extinction.

Thousands of years ago, a gap between the Colorado and South Platte drainages was breached by water from a glacial melt, allowing Colorado River cutthroats to cross the continental divide. These trout evolved into greenbacks, whose spots are larger than their ancestors'. In fact, they boast the largest spots of any trout.

Greenback cutthroats, highly vulnerable to hybridization, did not fare well when their native homes were stocked with rainbows. Introduced brook trout, though they didn't hybridize, nevertheless overran greenback streams. The compound effects of non-native species and human exploitation caused a sharp decline by the early part of the century, and the greenback was listed under the Endangered Species Act of 1973.

A recovery program—promptly engaged by the Colorado Division of Wildlife, the United States Fish and Wildlife Service, the National Park Service, and United States Bureau of Land Management—located only four streams and one lake with indigenous populations (Como, Hunter's, Apache, and Cascade creeks and Bear Lake). But more than a dozen new steams and five lakes have subsequently been successfully stocked with greenbacks, and in 1978 the status was changed from endangered to threatened—confirming this as one of the most successful trout-recovery programs in history. Appropriately, the official state fish of Colorado has been changed from the non-native rainbow trout to the greenback.

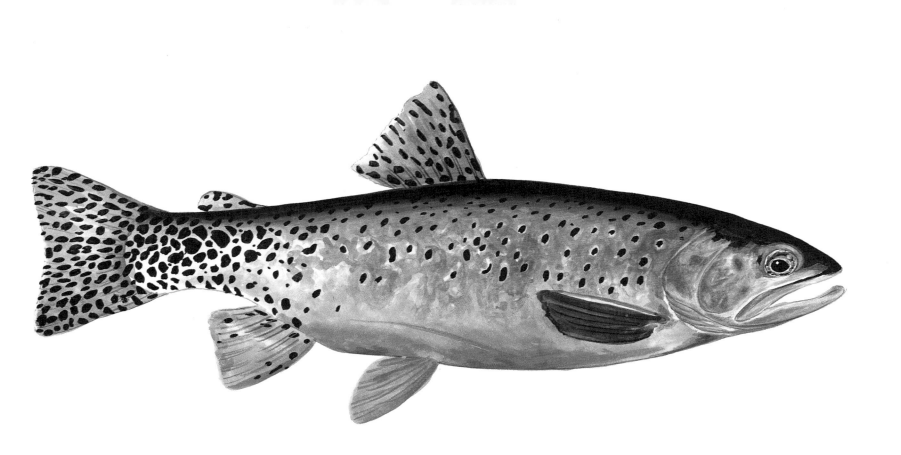

GREENBACK CUTTHROAT TROUT

Oncorhynchus clarki stomias

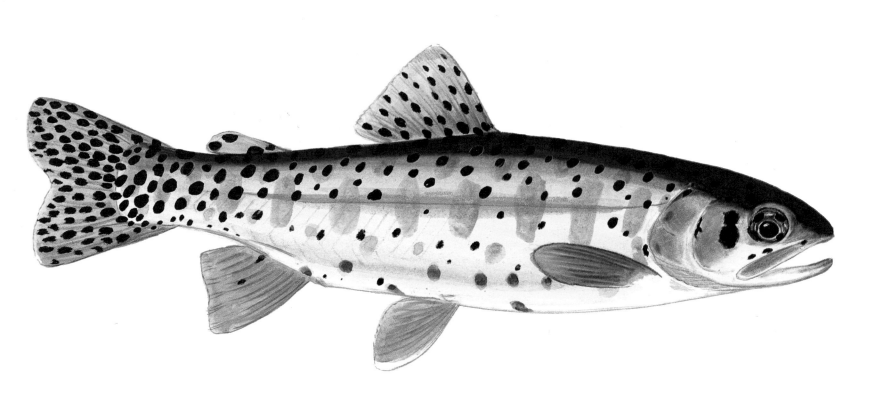

JUVENILE GREENBACK CUTTHROAT TROUT

Oncorhynchus clarki stomias

YELLOWFIN CUTTHROAT TROUT (extinct)

Four cutthroats were once native to Colorado: the greenback, the Colorado River, the Rio Grande, and the yellowfin. Of these, only the yellowfin is extinct. As described by Jordan and Evermann in *American Food and Game Fishes* (1902), "This interesting and beautiful trout is known only from Twin Lakes, Colorado, where it occurs in company with the greenback trout. The 2 are entirely distinct, the size, colouration and habits being notably different. The yellow-fin reaches a weight of 8 or 9 pounds while the other rarely exceeds a pound. The former lives on gravel bottom in water of some depth while the latter is a shallow-water trout running into small brooks. As a game-fish the yellow-fin trout has attracted much attention from local anglers by whom it is very highly regarded."

Only seven specimens are known to exist—not swimming in the wild, but in jars of formaldehyde in a museum. But a slim chance exists that this once popular game fish is alive somewhere in the world. The first federal hatchery in the western United States was built in Leadville, Colorado, near the ancestral home of the yellowfin. By 1889, the hatchery was propagating greenback and yellowfin cutthroats for stocking outside their native ranges. According to Jordan's autobiography, *The Days of a Man*, the yellowfin was introduced in France and from there in Germany, and it's likely that it was also distributed in different streams throughout Colorado. In his *Monograph on the Native Trout of Western North America*, Robert Behnke asks, "Might any offspring of those early introductions be lurking in some remote water, waiting to make their finder famous?"

What's known for certain is that rainbows were introduced to Twin Lakes at the turn of the century, and that the yellowfins were hybridized to extinction within ten years. The only place you'll ever see their glowing yellow fins and black star-like spots is probably within the pages of this book, in which we celebrate both what we have and what we've lost.

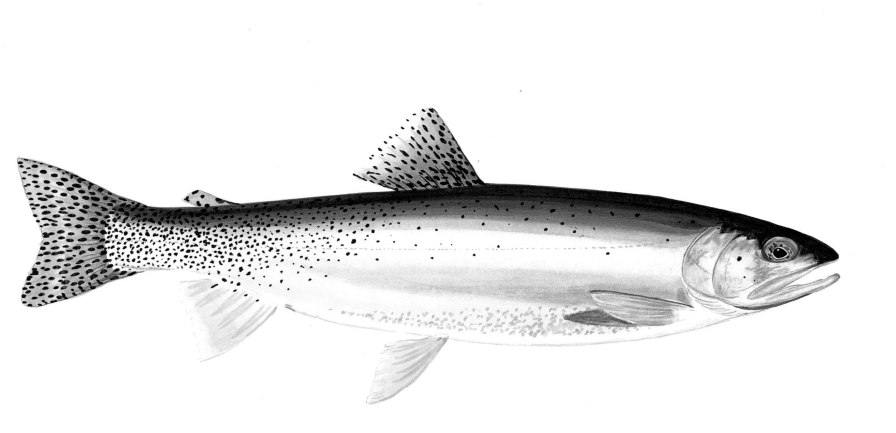

YELLOWFIN CUTTHROAT TROUT

Oncorhynchus clarki macdonaldi

RIO GRANDE CUTTHROAT TROUT
PECOS STRAIN OF THE RIO GRANDE CUTTHROAT TROUT

This colorful western trout was described by Dr. Charles Girard in 1857 as *virginalis*, I imagine because he felt its qualities suited a maiden: a pure, unsullied beauty, delicate and desirable.

Found at thirty-three degrees north latitude, the Rio Grande is the southernmost of all cutthroats; it is also the state fish of New Mexico.

Native to both Colorado and New Mexico, the fish is recognized in two forms—those of the Rio Grande drainage, and those of the headwaters of the Pecos River. The latter differs in having larger and more irregular spots, but both carry the red and orange colors of the southwestern desert.

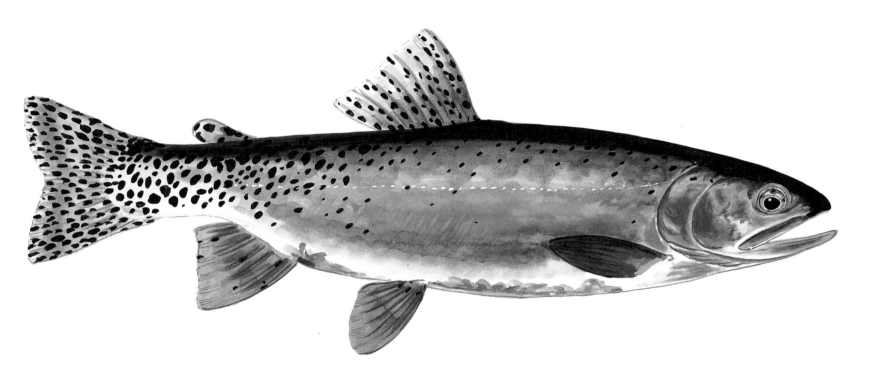

RIO GRANDE CUTTHROAT TROUT

Oncorhynchus clarki virginalis

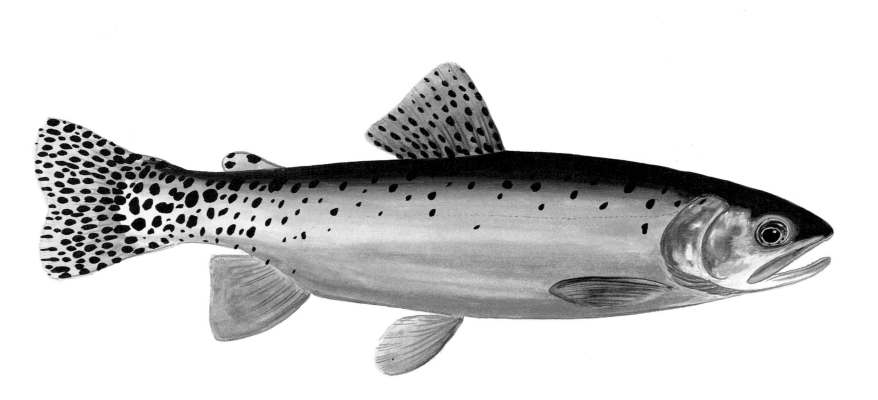

PECOS STRAIN OF THE RIO GRANDE CUTTHROAT TROUT

Oncorhynchus clarki virginalis

In what is now the semidesert badlands of Nevada, ancient Lake La-hontan once covered eight thousand square miles, was more than five hundred feet deep, and, according to native folklore, held fish weighing upwards of sixty pounds—the largest cutthroats of all. And though by now much diminished, this pharaoh of western trout lives on in what is now called Pyramid Lake. In color, these trout reflect the coppery red and ocher hues of the Nevada hills, scattered with black spots.

After the great lake receded, the Lahontan gradually found homes in Pyramid, Walker, and Tahoe lakes, and in the Truckee, Humboldt, Quinn, and Carson rivers. They range in kind from tiny trout in brooks on the eastern slope of the Sierra Nevada range to the leviathans once found in Pyramid and Tahoe lakes.

The largest strain, once abundant in Pyramid Lake, is now extinct, and fish like the forty-one-pound world record caught by Paiute tribesman John Skimmerhorn in 1925 are a phenomenon of the past. This demise started in 1905, when a dam was built on Lahontan spawning grounds in the Truckee River, about thirty miles from the mouth of Pyramid Lake. As demands for water increased, less water was finding its way to the lake, and eventually there wasn't enough for the spawning run. In 1938, under the merciless Nevada sun, the final run of great Lahontan cutthroat ascended the drying river, the average fish weighing twenty pounds.

Pyramid Lake Lahontans were stocked in various Nevada streams at the beginning of the century. According to Behnke, one of these transplants exists today in Donner Creek, on Pilot Peak on the Utah-Nevada border. Though the gene pool is small, the Pyramid Lake cutthroat strain may be salvageable from this population.

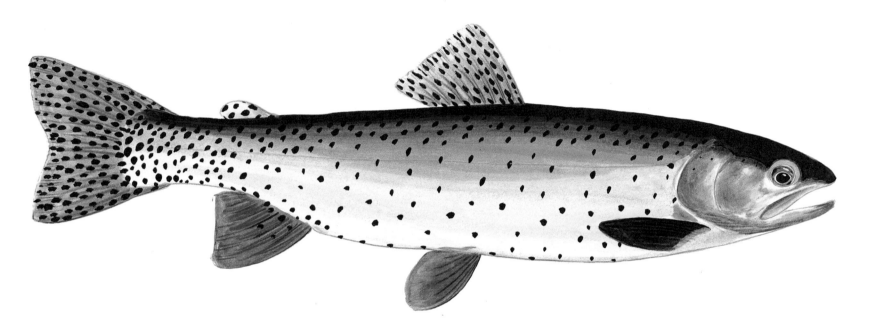

LAHONTAN CUTTHROAT TROUT

Oncorhynchus clarki henshawi

In Greek, *Selene* is "goddess of the moon," and *iris* is "rainbow." This exquisite and celestial trout is a subspecies closely related to the Lahontan cutthroat. What makes the Paiute unique is the near absence of spots on the body. Except for the few spots on the dorsal, adipose, and caudal fins, this trout is virtually nude.

In 1973 the Paiute was listed as an endangered species, but in 1975 its status was changed to threatened in order to allow it to be managed as a sport fish. The rare Paiutes were subsequently introduced into other small creeks of eastern California, though their numbers remain scarce.

This trout is endemic to the Upper Carson River, just south of the notch on the eastern border of California. In 1912, a Basque shepherd carried a few of these delicate fish in a can full of water above the falls that separate Silver King Creek from the Upper Carson River. Owing to the introduction of non-native trout, Paiutes no longer exist in the Carson, and if it weren't for that single shepherd, we would no longer have the moon trout to gaze at. Today, a full-time "river keeper" is employed by the state of California to guard the trout of Silver King Creek.

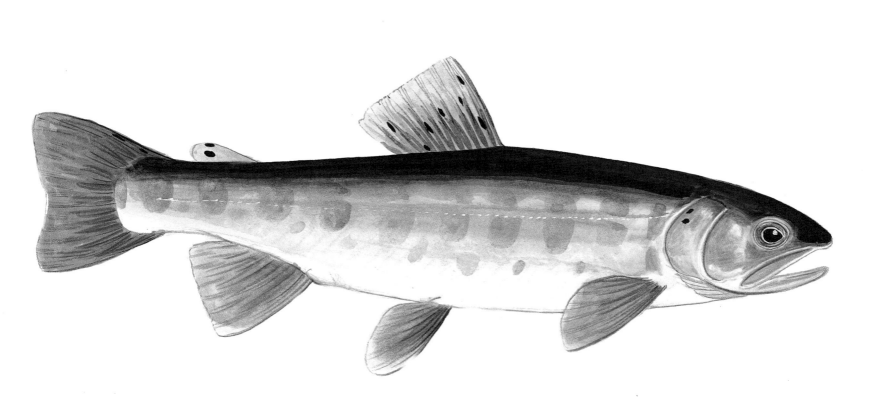

PAIUTE CUTTHROAT TROUT

Oncorhynchus clarki seleniris

The Alvord cutthroat, first brought to scientific attention by Carl Hubbs in 1934, is now considered extinct in its pure form. The Alvord basin of southeastern Oregon and northwestern Nevada is all that remains of ancient Lake Alvord. Here, in Trout Creek and Virgin Creek, this cutthroat was at home, but the introduction of rainbows wiped it out.

In 1984, a slightly hybridized population was discovered in the headwaters of Virgin Creek. Some of the fish matched Hubbs's descriptions, notably a "rose hue on dorsal areas and deep red on the sides." What was astounding about these cutthroats was their size—up to twenty inches in a stream no more than three feet wide. Two years later, the Nevada Department of Wildlife removed twenty-six of the most Alvord-looking specimens and transplanted them into Jackson Creek in the Jackson Mountains of the Lahontan basin.

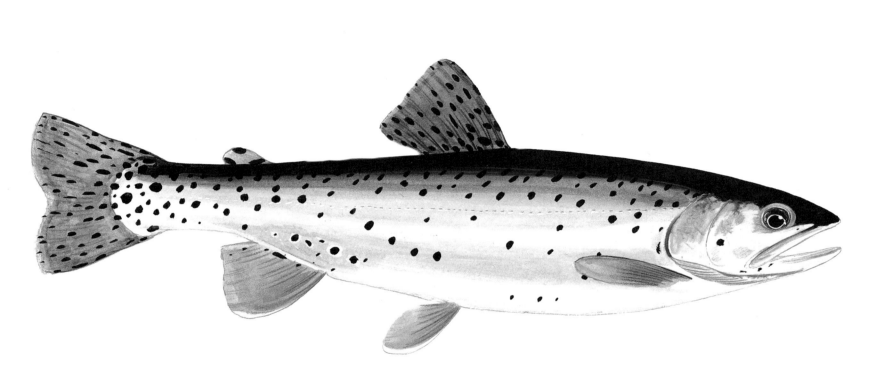

ALVORD CUTTHROAT TROUT

Oncorhynchus clarki alvordensis

WILLOW-WHITEHORSE CREEK CUTTHROAT TROUT

In the southwestern corner of Oregon, in the Trout Creek Mountains, this cutthroat lives in the two streams, Willow and Whitehorse, for which it's named. In the middle of this desert it has endured flood, fires, drought, and glaciation—yet the greatest threat today comes from livestock, which cause erosion and siltation by grazing on streamside foliage. COWS KILL TROUT, reads one bumper sticker—no doubt on an angler's vehicle.

Like the Alvord, these cutthroats evolved from Lahontan trout left in isolation when the ancient great lakes of glacial melt receded. Their homes today are not connected to any major river system—their lifeblood comes from the mountains and dries up in the desert valleys. In color and appearance, they resemble the Lahontans, typically having fewer and larger spots.

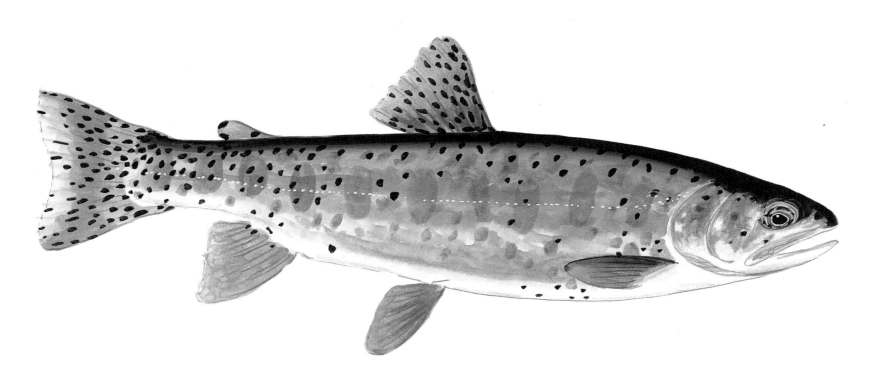

WILLOW-WHITEHORSE CREEK CUTTHROAT TROUT

Oncorhynchus clarki subsp.

HUMBOLDT CUTTHROAT TROUT

The Humboldt, another evolutionary variant of the Lahontan cut-throat, is native to the Humboldt River drainage in Nevada. It has adapted to conditions that seem distinctly untrouty—such as evaporating pools of intermittent streams, where it has been found in summer in healthy condition.

Humboldts wear the same ruddy colors, though their spots tend to be larger and concentrated toward the tail. Tributaries of the Marys River in the Humboldt National Forest—Frazier, Sherman, and Hanks creeks—have some of the healthiest populations left. These trout can grow to fifteen inches, which is relatively large for such small streams. Tributaries of the Reese River have Humbolts, and five populations of a slightly divergent type exist in the headwaters of the Quinn River.

In 1973 the Humboldt was listed as endangered, and changed to threatened two years later. The ongoing threats are from irrigation, which draws more and more water from these small streams, and the encroachment of livestock.

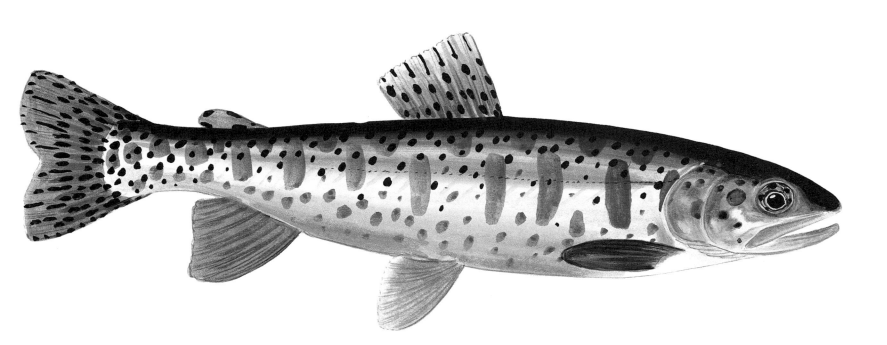

HUMBOLDT CUTTHROAT TROUT

Oncorhynchus clarki subsp.

BEAR LAKE STRAIN OF THE BONNEVILLE CUTTHROAT TROUT
PROVO RIVER STRAIN OF THE BONNEVILLE CUTTHROAT TROUT
SNAKE VALLEY STRAIN OF THE BONNEVILLE CUTTHROAT TROUT

The Bonneville cutthroat occupied the waters of ancient Lake Bonneville some ten to seventy thousand years ago. This lake of glacial melt had an area the size of present-day Lake Michigan and a maximum depth of nine hundred feet. As this inland sea receded, the cutthroat became isolated in streams and lakes from which it takes its common names. There are three main types that have evolved, and they exist in pure populations—forty-one in all—in Utah, Idaho, Nevada, and Wyoming.

One summer in high school I was invited by a Mormon friend to spend some time fishing in Utah. We arrived in Salt Lake City in July, and spent a month driving around the state in his grandfather's old pickup truck. I'd already read about the Utah trout in Jordan and Evermann's *American Food and Game Fishes*: "In partly alkaline waters, such as Utah Lake, this trout reaches a very large size, examples of 8–12 pounds being not uncommon. In these waters it is very pale in colour, the dark spots being few and small, and mostly confined to the back. The Utah Trout is found in the streams and lakes of Utah west of the Wasatch Mountains, especially in Bear, Provo, Jordan, and Sevier rivers, and in Utah Lake, where it is a very abundant and important food fish." Since that was written, nearly a century ago, what we now call the Bonneville

cutthroat has been wiped clean from essentially all those waters. The Jordan River, once filled with these fish, is now known as the Salt Lake City Sewage Canal; Utah Lake, to which it is connected, is in no better condition. But we also fished the Provo, which turned out to be a wonderful wild trout river, though brown trout had replaced the cutthroats. In Beryl—the smallest and most isolated village in the state—we fished Pinto Creek, a pleasant winding stream lined with willows in a desert landscape of rocky crags and cacti. Bonneville cutthroats once swam in this oasis, which now held rainbows with traces of cutthroat hybridization on their fins and sides. The trout were as wild and rosy as the cactus fruit that lined the banks, but not native.

On the drive back to Salt Lake, we stopped in the town of Fountain Green to visit the only hatchery in the world that raised Bonneville cutthroat trout. The trout keeper explained that they take the eggs from spawning, pure fish in Bear Lake, on the Utah-Idaho border, and ship the fertilized eggs down to Fountain Green, whose spring, he noted, has the highest water quality in the state. Once they've hatched and reached a modest size, they are stocked in Strawberry Reservoir. I saw only fingerlings in the raceways, none more than two inches long, and asked if there were any bigger ones. The trout keeper got some nets and

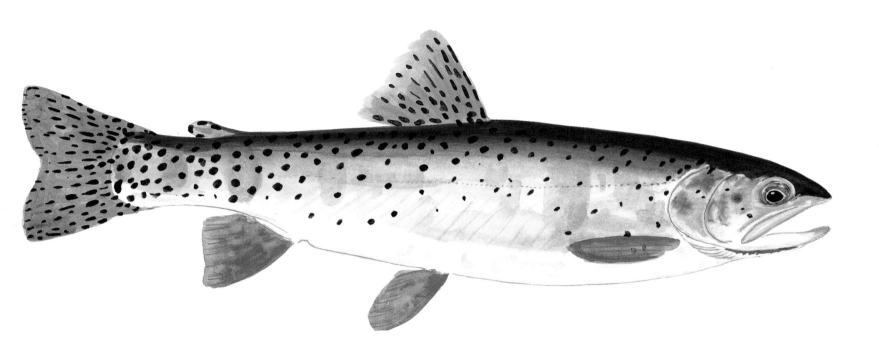

BEAR LAKE STRAIN OF THE BONNEVILLE CUTTHROAT TROUT

Oncorhynchus clarki utah

led us to a nearby irrigation ditch, where a few Bonnevilles had escaped and grown to eleven inches or so in their effort to become wild once more. We managed to catch a few, which I photographed for posterity. They were little jewels, like hummingbirds or butterflies—emerald and gold, with a necklace of parr marks and dotted with fine black spots. We held them in our hands, then released them in the golden sun of a Utah summer afternoon.

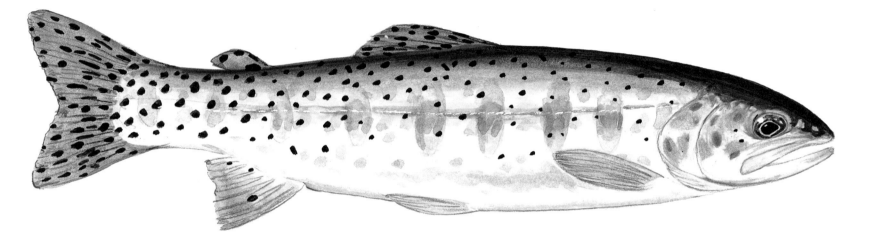

PROVO RIVER STRAIN OF THE BONNEVILLE CUTTHROAT TROUT

Oncorhynchus clarki utah

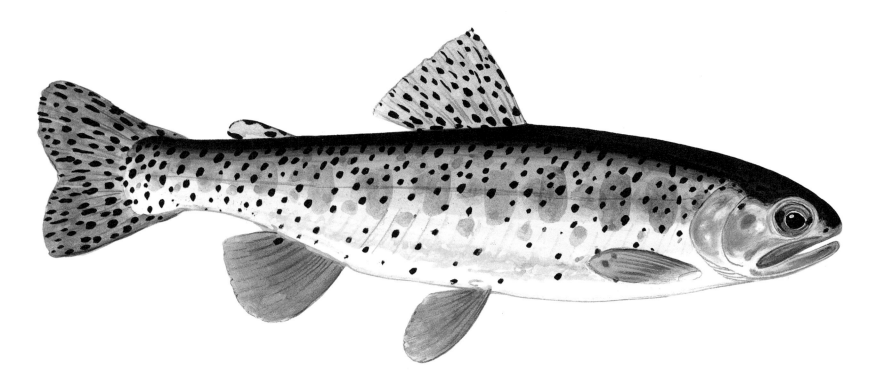

SNAKE VALLEY STRAIN OF THE BONNEVILLE CUTTHROAT TROUT

Oncorhynchus clarki utah

SNAKE RIVER FINE-SPOTTED CUTTHROAT TROUT

Davey Jackson and his cohorts Jim Bridger, William Sublette, and Jedediah Smith were some of the first non-natives to view *Les Grands Tétons*. As a fourteen-year-old camper in this Wyoming paradise, I liked to believe that things hadn't changed much since their time. The rivers still flowed, and the sky was still that distant pale blue of a blind man's eye. It was July on the Gros Ventre River, and the dry exoskeletons of stonefly nymphs promised that trout would be feeding. I was here to catch the Snake River fine-spotted cutthroat.

Its native range is the Snake River drainage between Jackson Lake and the Palisades Reservoir, including such major tributaries as the Salt and Gros Ventre rivers. The predominant fish above the lake and below the reservoir is the Yellowstone cutthroat, but this section of the Snake was isolated long ago by glacial dams, and the fine-spotted trout evolved. Unlike most other cutthroats, is does not readily hybridize with rainbows, and it has been transplanted extensively outside its native range.

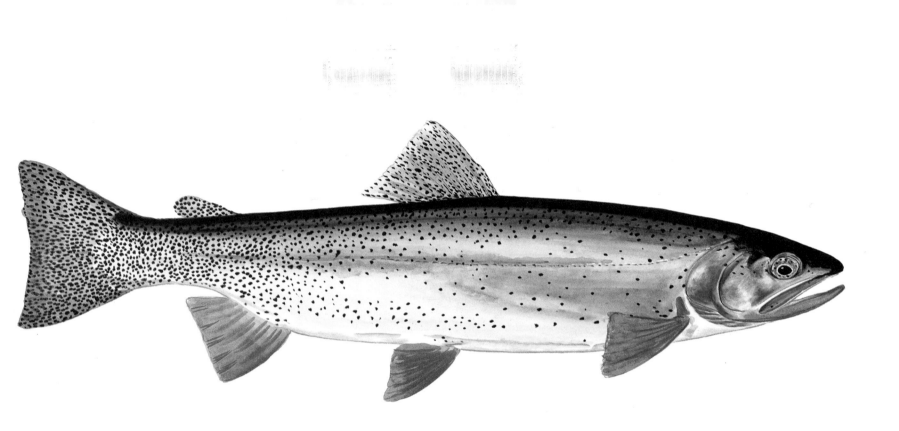

SNAKE RIVER FINE-SPOTTED CUTTHROAT TROUT

Oncorhynchus clarki behnkei

Below Yellowstone Lake, a nine-mile stretch of river open to catch-and-release fishing is the home of one of the greatest native cutthroat populations on earth. These fish are coppery yellow on the sides, with hints of lavender and indigo, and their round, moderate-sized spots are concentrated toward the tail. They eagerly take the anglers fly and, when released, are often caught several more times.

These cutthroats invaded the Yellowstone River in ancient times. They came up the Snake and populated the headwaters of Pacific Creek, which in times of high water was connected to Atlantic Creek, which is on the east side of the continental divide and ends up in the Yellowstone. This transfer is thought to have occurred some three-quarters of a million years ago, and for a near eternity, the Yellowstone cutthroat and its ancestors swam these waters along with only one other native fish, the longnose dace.

America's first national park, Yellowstone had received by 1889 five thousand brook, brown, and rainbow trout for stocking the area streams. Surprisingly, this had little effect on the native cutthroats, which tend not to hybridize within their native range. Still, introduc-ing non-native fish is highly illegal and subject to severe penalties. A current threat is the recent, unauthorized, and mysterious introduction of lake trout to Yellowstone Lake. No one is certain how they made their way into the lake, but as a predator of juvenile cutthroats they could be very detrimental.

The Yellowstone cutthroat has been widely distributed outside its native range. The first hatchery on the lake was built in 1899, and this fish soon became the cutthroat of choice for widespread stocking. Seeded extensively throughout the western United States, it has not yet been introduced successfully in the East.

A divergent strain was once native to Idaho's Waha Lake. According to Jordan and Evermann's *American Food and Game Fishes*, the average length of these fish was six to seven inches, and they occasionally grew to three pounds. They are now extinct, but a trout of similar appearance survives in Sedge Creek, a tributary of Yellowstone Lake. The creek is isolated from the lake by a bubbling geothermal sulfur pit called Turbid Lake. These trout were thought to have been trapped there some five thousand years ago.

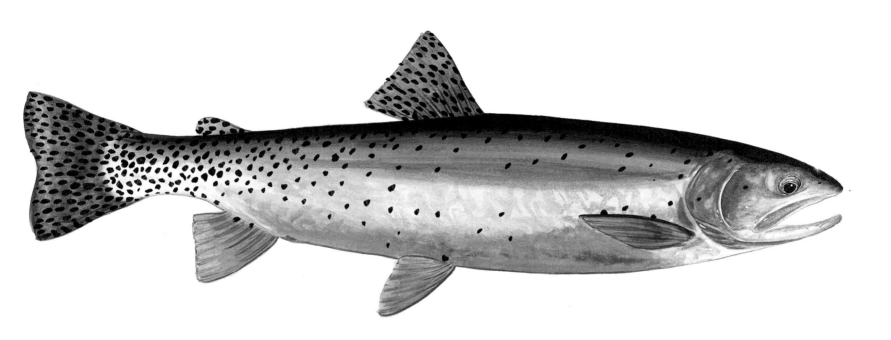

YELLOWSTONE CUTTHROAT TROUT

Oncorhynchus clarki bouvieri

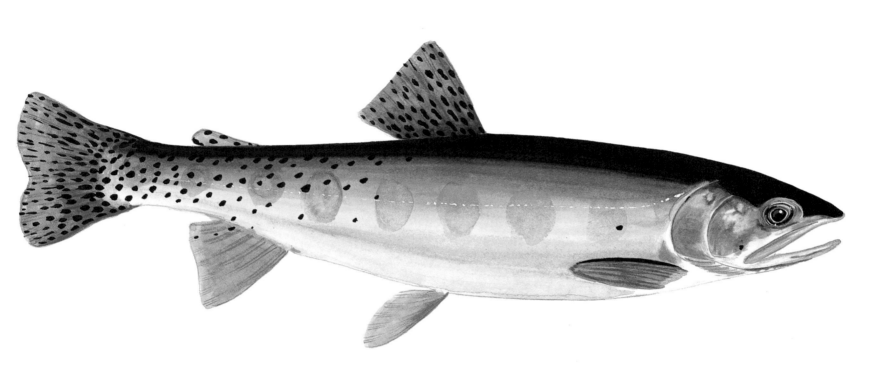

SEDGE CREEK OR WAHA LAKE CUTTHROAT TROUT

Oncorhynchus clarki bouvieri

WESTSLOPE CUTTHROAT TROUT
MOUNTAIN CUTTHROAT TROUT

The Missouri River at Great Falls is where Lewis and Clark first collected cutthroat trout in 1805. As Lewis described in his journal: "These trout are from sixteen to twenty three inches in length, precisely resemble our mountain or speckled trout [brook trout] in form and the position of their fins, but the specks on these are of a deep black instead of the red or gold of those common in the U' States. These are furnished with long teeth on the pallet and tongue and have generally a small dash of red on each side behind the front ventral fins; the flesh is of a pale yellowish red, or when in good order, of a rose red." In 1853, a surgeon with the Pacific Railroad Survey collected specimens and sent them to Girard, who in 1856 named this new species *lewisi* in the explorer's honor. Their native range embraces most of western Montana and northern Idaho; more specifically, the upper Missouri River basin on the east side of the divide downstream to Fort Benton, Montana (including tributaries—Milk, Marias, and Judith—below Fort Ben-

ton) and the upper Columbia River basin on the west side of the divide.

A divergent form, the mountain cutthroat, comes from the headwaters of the upper Columbia in British Columbia and from those of the John Day River, high in Oregon's Greenhorn Mountains. The vivid yellows and reds of both fish grow more intense toward spawning. Each is profusely spotted, save for a bare spot that reaches from the pectoral fin to the anterior part of the anal fin.

The westslope spawns in spring from March to July, and lake dwellers will travel nearly a hundred miles up tributaries on their runs. Feeding on insects and crustaceans, they are not piscivorous. Introductions of non-native fish have been disastrous. Kokanee salmon compete with them for zooplankton, lake trout prey on them, and eastern brook trout displace them in headwater streams. Thankfully, many pure populations remain (that of the South Fork of the Flathead River in the Bob Marshall Wilderness of Montana being a prime example).

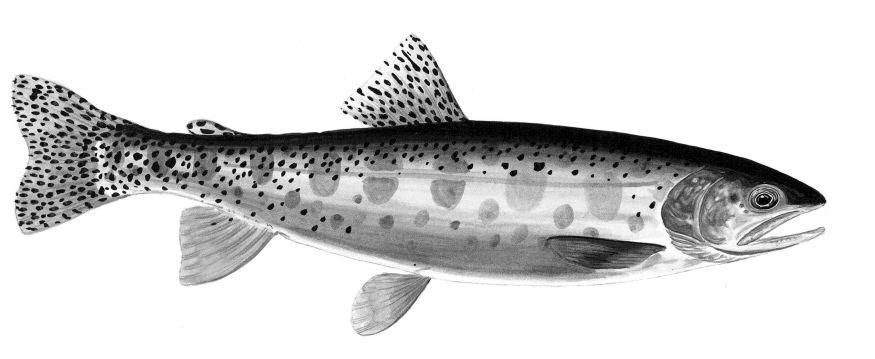

WESTSLOPE CUTTHROAT TROUT

Oncorhynchus clarki lewisi

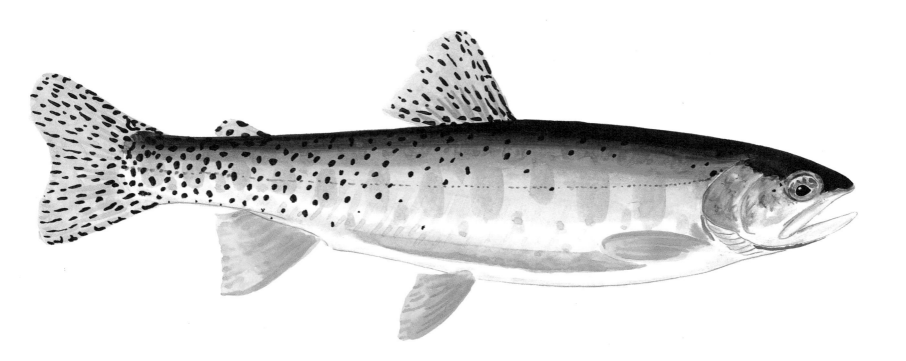

MOUNTAIN CUTTHROAT TROUT

Oncorhynchus clarki alpestris

Along with the westslope, Yellowstone, and Lahontan, this is considered one of the four major subspecies of cutthroat.

Sea-run, blueback, harvest trout, and (my personal favorite) ghost trout are all colloquial names for this heavily speckled West Coast beauty—the only anadromous cutthroat. Coastal cutthroats do not migrate as far out to sea as the Pacific salmon, but feed instead in the estuaries, biding their time before spawning in rivers in the late winter or early spring. The coastal cutthroat is the genesis of all cutthroat—an evolutionary ancestor that held its taste for salt water, while all that evolved from it made their home in fresh.

The most widely distributed of any native form of cutthroats, they cover the Pacific shore and islands from Alaska to as far south as Northern California. They range as far inland as the Cascade mountains in Oregon and high headwaters of the Skeena River in British Columbia. Their trademarks are profuse spotting and silver sides splashed with a rose and violet wash. Unlike their sea-running cousins, lake-dwelling coastal cutthroats often have copper, orange, and yellow coloration; in the past these fish were given separate classifications, but those have been abandoned.

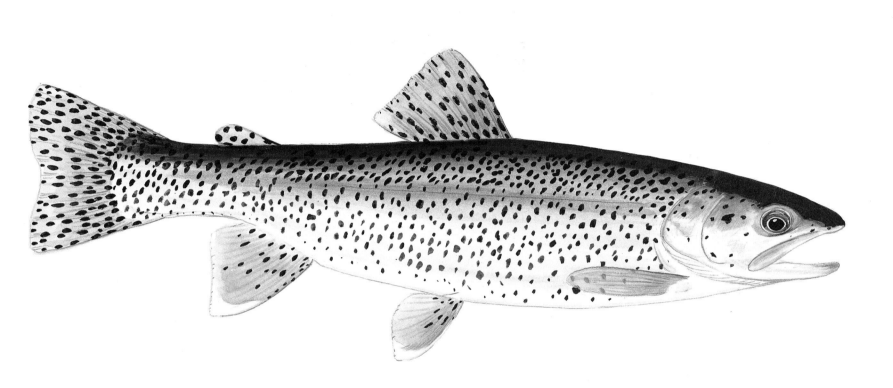

COASTAL CUTTHROAT TROUT

Oncorhynchus clarki clarki

BROWN TROUT AND ATLANTIC SALMON

The Atlantic salmon, *Salmo salar*, is an anadromous trout native to coasts on both sides of the ocean that bears its name. The brown trout, an immigrant from Europe, is closely related to the Atlantic salmon, with which it coexists in rivers of the British Isles. Both spawn in the fall, and when they are young it's very difficult to distinguish between them.

VON BEHR BROWN TROUT
LAKE STRAIN BROWN TROUT
SEA-RUN BROWN TROUT

I prize the brown trout for its remarkable variation in color and form. In lakes where brownies feed on fish, their sides shine like silver, in small creeks their flanks are often speckled with red, orange, and gold. Their astounding range includes the British Isles, the mountains of continental Europe as far east as the White Sea drainage in Russia, Iceland, the Atlas Mountains of north Africa, Sardinia, Corsica, the Turkish headwaters of the Tigris and Euphrates, Greece, Albania, and Lebanon. Since the first successful transplant of eggs from the famed River Itchen in Britain to Tasmania in 1864, populations have been established in New Zealand, Australia, the Falkland Islands, Newfoundland, Nova Scotia, south Ontario, Alberta, the United States, Argentina, Chile, Peru, Bolivia, Ecuador, Colombia, Venezuela, South Africa, and the mountains of India.

Brown trout came to the United States in 1883 from streams in the Black Forest, a gift from Baron von Behr, president of the German Fisheries Society, to Fred Mather, the American delegate whom he had met at the International Fisheries Exposition in Berlin in 1880. Eighty thousand eggs arrived in February of that year; some were brought to the Cold Spring Harbor Hatchery on Long Island, but most were sent to the United States Fish Commission Hatchery in Northville, Michigan, where more than thirteen hundred were successfully hatched. The first documented release was in April 1884, in the Pere Marquette River of Michigan. Many other shipments from different parts of Europe subsequently arrived, and by 1900 brown trout had been released in thirty-eight states. Their adaptability and hardiness allowed them to grab hold, and thirty-four states now have wild populations.

In Europe, more than fifty different species of brown trout were once recognized—each from watersheds that fostered trout with different habits and appearances. For example, three species were counted in Lough Melvin, Ireland: the sonaghen (*Salmo nigrippinis*), the gillaroo (*Salmo stomachicus*), and the ferox (*Salmo ferox*). The gillaroo, which fed on crustaceans and snails, had a thicker stomach lining to handle such coarse meals; and because such foods are high in carotene, the gillaroo had dark red flesh and beautiful red spots on its sides. The sonaghen, also called the black-finned trout, had many large black spots over a silvery background. The ferox seemed to combine aspects of the gillaroo and sonaghen.

In recent years, the general trend has been to toss all this genetic diversity into a single highly variable pool: *Salmo trutta*, or "salmon trout," named by Linnaeus in 1758. This conveniently pushes a taxonomic nightmare under the rug. Our current system of classification isn't capable of sorting out this genetic diversity, and we must respect

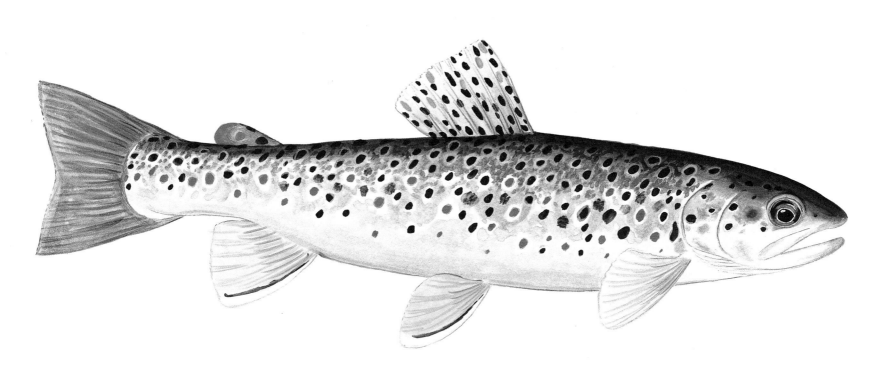

VON BEHR BROWN TROUT

Salmo trutta fario

the fact that we cannot bring total organization to the ever changing process of evolution. The beautiful diversity of this trout must be accepted, and then we must work to preserve it.

I've included the brown trout among these native North American fish because of the tremendous impact it has had. It has outlasted the brook trout in streams degraded by logging or otherwise polluted by the encroachment of civilization. It has survived its initial unpopularity in America, being not only foreign but also hard to catch, and has worked its way into the fabric of modern fly fishing. Because it is often very selective toward offerings presented with the fly rod, it has won the acclaim of sportsmen. And because it dwells in places of beauty and is a creature of beauty itself, it has won the heart of anyone who loves nature. The paintings I've chosen display the three major types of brown trout: *Salmo trutta fario*, the small woodland fish sent to us by von Behr; *Salmo trutta levenensis*, a trout of the lakes; and *Salmo trutta trutta*, a sea-run fish.

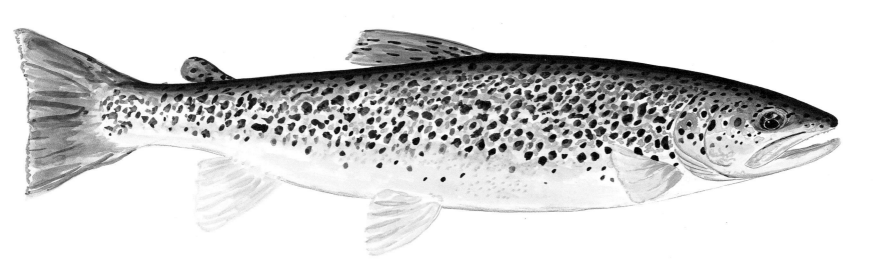

LAKE STRAIN BROWN TROUT

Salmo trutta levenensis

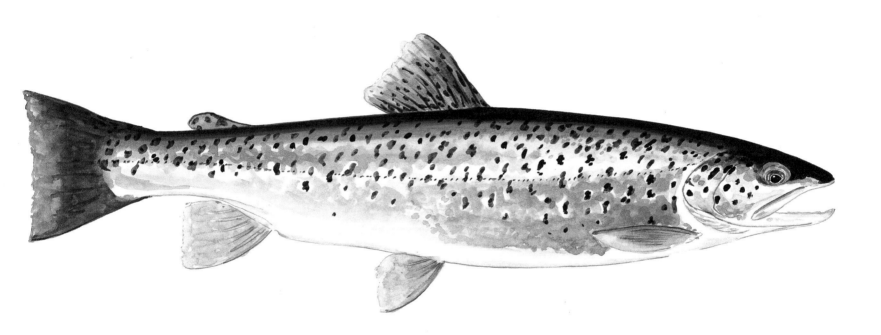

SEA-RUN BROWN TROUT

Salmo trutta trutta

ATLANTIC SALMON
SEBAGO SALMON
OUANANICHE SALMON

Atlantic salmon born in streams on both sides of the ocean come to feed in the Davis Strait, between Greenland and Baffin Island. Foraging on small baitfish called capelin, they spend up to four years here before navigating to their natal streams. They surmount seemingly impossible barriers to ascend the coastal rivers; their primary glands—pituitary, kidney, and adrenal—shrink, and they do not feed. They spawn in the fall and spend the winter quietly finning in the gentle rills. In the spring, if they have survived their rigors, they return to the sea and their glands magically regenerate. A small percentage of Atlantic salmon spawn a second time, though some will spawn three or four times. Such return spawners are immense; the world record, from the Tana River of Norway, weighed seventy-nine pounds.

The delights of Atlantic salmon fishing are well documented, and by now it is a venerable tradition. Anglers from New York and New England time their northward migration to coincide with the salmon's westward travel, then they tempt them to hit fanciful flies tied with feathers of rare and beautiful tropical birds, often using hand-crafted rods and reels.

Although the salmon is highly respected, its rivers have not escaped destruction. The Connecticut was once the greatest Atlantic salmon river of our continent. The salmon would ascend in such abundance that farmers would pitchfork them from the river to fertilize the cornfields, and wagons crossing smaller tributaries would kill several by accident. Servants sometimes even stipulated in their contracts that salmon not be served at meals more than three times a week. These generous times, of course, are long gone. In 1798, a dam was built by the Upper Locks and Canal Company a hundred or so miles upstream of the river's mouth, blocking the spawning runs. Within ten years the salmon had all but disappeared, and by 1810 they were extinct. A project to return salmon to the Connecticut has been in the works for more than thirty years at a cost of over $200 million—yet no major success has been seen. Atlantic salmon fishing has been degraded in Maine as well, and remains healthy only in such famous Canadian rivers as the Restigouche and Miramichi.

Inland anglers have far better chances fishing for landlocked salmon, which are fairly abundant and have been introduced widely outside

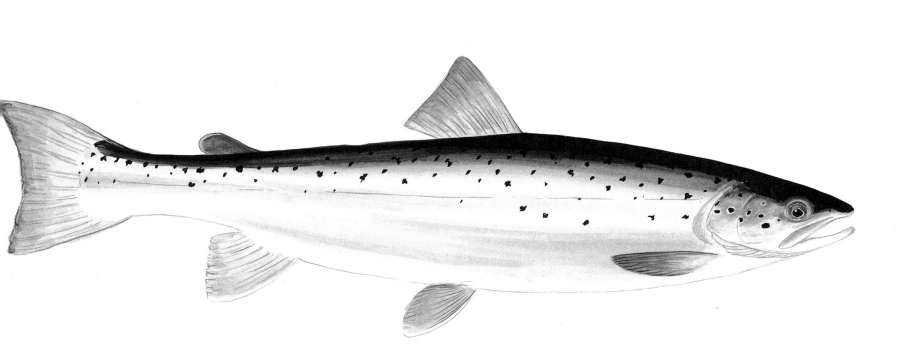

ATLANTIC SALMON

Salmo salar salar

their native range. For anglers on Sebago Lake in Maine, ice-out is the beginning of the annual run of smelt up tributary streams to spawn— and the time to catch the landlocks that feed on them. Two forms of landlocked salmon exist. The Sebago, *Salmo salar sebago*, is caught in lakes of northern New England. And the ouananiche, *Salmo salar ouananiche*, is found in tributaries of the St. Lawrence River. The latter isn't truly landlocked, however; it has access to the sea, but chooses not to use it.

Because of its awesome presence, I've made a place among our native trout for the *Salmo salar*—the leaper—considered to be the most sporting fish alive.

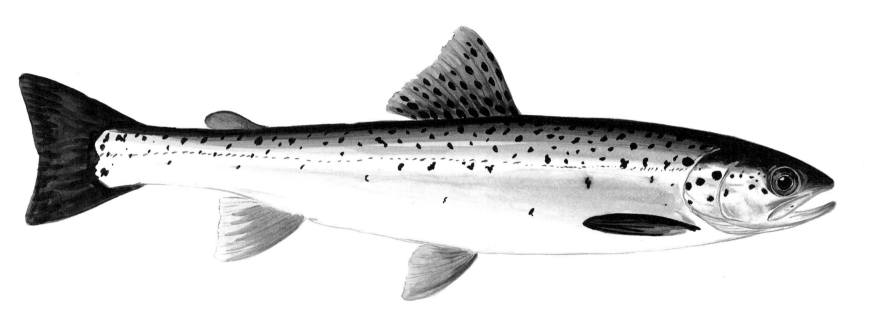

SEBAGO SALMON

Salmo salar sebago

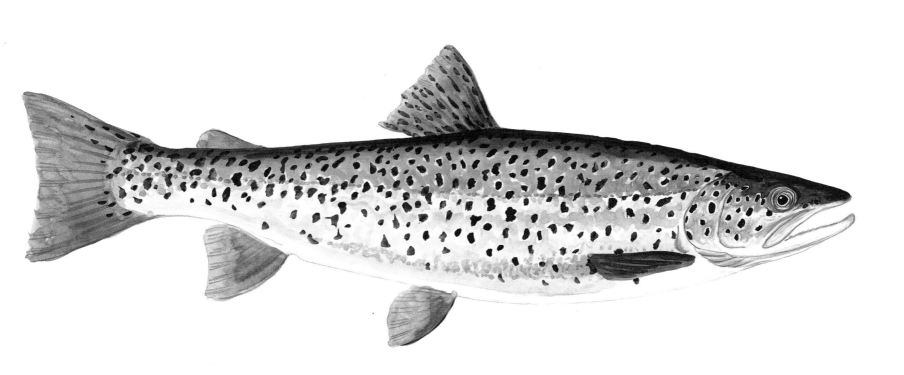

OUANANICHE SALMON

Salmo salar ouananiche

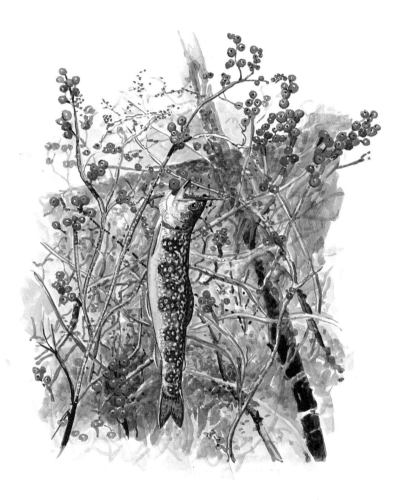

ACKNOWLEDGMENTS

The work of many trout enthusiasts over several hundred years has been indispensable in the completion of this book. To wildlife agencies I owe many thanks, for prompt answers to my questions about native trout and for their efforts to conserve them.

One day, fishing illegally on Connecticut's Aspetuck Reservoir with my friend, I was caught by a warden named Joseph Haines. In the five years since, he has taught me much about trout, fish of the ocean, birds of the sky, plants of the woods, and the pleasures of eating wild things—from mushrooms to fish and game. It is a sweet pleasure to be in the presence and under the instruction of such a knowledgeable woodsman. Taylor Hoyt has been my friend since kindergarten, and around the age of nine we both discovered the wonders of fishing independently. He has joined me on the majority of my outings, and I thank him for his unmatched dependability.

There are a host of other people I wish to thank: my uncle, Frank Prosek, for bluefish trips in my childhood, before he left to fish and hunt in heaven; Stephen Bartlett and Josh Blackwelder; Lennie Grimaldi; Bruce Hawley, Don Halsted, and Dick Demarco, for trips to their private trout streams; Ben Hawley, for hours of bass fishing on Kaechele Pond; Kevin Dunn, for being a patron of my artwork; Dean John Loge at Yale, for reviewing the text; and Gary Fisketjon at Knopf, for having faith in an eighteen-year-old to complete this book.

RECOMMENDED READING

Bashline, L. James. *Atlantic Salmon Fishing*. Harrisburg, Pa.: Stackpole Books, 1987.

Behnke, Robert J. *Monograph on the Native Trout of Western North America*. Bethesda, Md.: American Fisheries Society, 1992.

Bergman, Ray. *Trout*. New York: Alfred A. Knopf, 1952.

Calabi, Silvio. *Trout & Salmon of the World*. Secaucus, N.J.: Wellfleet Press, 1990.

Carroll, David M. *Trout Reflections*. New York: St. Martin's Press, 1993.

Coffin, Patrick D. "Lahontan Cutthroat Trout Fishery Management Plan for Humboldt River Drainage Basin." Nevada Department of Wildlife, Species Management Plan, Reno, 1983.

———. "Nevada's Native Salmonid Program: Status, Distribution and Management." Nevada Department of Wildlife, Reno, 1988.

Cutter, Ralph. *Sierra Trout Guide*. Portland, Ore.: Frank Amato Publications, 1991.

The Fishes of New Mexico. Albuquerque: University of New Mexico Press, 1990.

Goode, George Brown. *American Fishes—A Popular Treatise upon the Game and Food Fishes of North America*. New York: Standard Book Co., 1888.

Gresswell, Robert E. *Status and Management of Interior Stocks of Cutthroat Trout*. Bethesda, Md.: American Fisheries Society, 1988.

Hewitt, Edward Ringwood. *Secrets of the Salmon*. New York: Charles Scribner's Sons, 1922.

———. *Telling on the Trout*. New York: Charles Scribner's Sons, 1926.

Jardine, Charles. *Fly Fishing*. New York: Random House, 1991.

Jordan, David Starr. *Leading American Men of Science*. New York: Henry Holt and Co., 1910.

———. *The Days of a Man: Being Memories of a Naturalist, Teacher, and Minor Prophet of Democracy*, vols. 1 and 2. Yonkers-on-Hudson, N.Y.: World Book, 1922.

Jordan, David Starr, and Barton Warren Evermann. *American Food and Game Fishes*. New York: Doubleday Page & Co., 1902, 1923.

Kendall, William Converse. *The Trout and Charrs of New England*. Boston: Boston Society of Natural History, 1914.

LaFontaine, Gary. *Caddisflies*. New York: Winchester Press, 1981.

Marinaro, Vincent. *A Modern Dry-Fly Code*. New York: G. P. Putnam's Sons, 1950.

———. *In the Ring of the Rise*. New York: Lyons and Burford Publishers, 1976.

Quackenbos, John D. *The Geological Ancestors of the Brook Trout*. New York: Anglers' Club of New York, 1916.

Schnell, Judith, and Judith Stolz, et al. *Trout*. Harrisburg, Pa.: Stackpole Books, 1991.

Schwiebert, Ernest George. *Trout*. New York: E. P. Dutton, 1978.

Smith, Robert H. *Native Trout of North America*. Portland, Ore.: Frank Amato Publications, 1984.

Sternberg, Dick. *Freshwater Gamefish of North America*. New York: Prentice Hall Press, 1987.

———. *Trout*. New York: Prentice Hall Press, 1988.

Taylor, C. Barr. *Shadow of the Salmon*. New York: HarperCollins, 1994.

Thwaits, R. G., editor. *Original Journals of the Lewis and Clark Expedition*. New York: Dodd and Mead, 1904.

Walden, Howard T. *Familiar Freshwater Fishes of America*. New York: Harper & Row, 1964.

Willers, Bill. *Trout Biology*. New York: Lyons and Burford Publishers, 1991.

A NOTE ON FINDING PLACES WHERE
RARE TROUT DWELL

Write or call the appropriate state department of wildlife for information on where to catch native trout. For the distribution of cutthroat trout, the Gresswell book is very helpful. For distribution of all western trout, the Behnke book is helpful (order a copy through your local bookstore or write the American Fisheries Society, 5410 Grosvenor Lane, Suite 110, Bethesda, MD 20814). If you seek rare trout in their native streams, please practice catch and release.

A NOTE ON THE TYPE

The text of this book was set in Van Dijck, a modern revival of a typeface attributed to the Dutch master punch cutter Christoffel van Dyck (c. 1606–69). The revival was produced by the Monotype Corporation in 1937–38 with the assistance, and perhaps over the objection, of the Dutch typographer Jan van Krimpen. Never in wide use, Monotype Van Dijck is nonetheless a typeface of outstanding detail and precision. It has the familiar and comfortable qualities of the types of William Caslon, who used the original Van Dijck as the model for his famous letter.

Printed and bound by Berryville Graphics, Berryville, Virginia
Designed by Peter A. Andersen